FLOATING CITIES

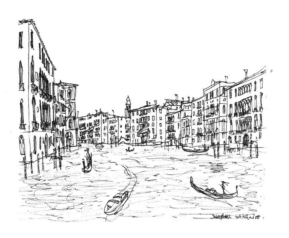

FLOATING CITIES

Venice, Amsterdam, Leningrad – and Moscow

STEPHEN WILTSHIRE

with a Foreword by Dr Oliver Sacks

Summit Books
New York London Toronto Sydney Tokyo Singapore

SUMMIT BOOKS
Simon and Schuster Building
Rockefeller Center
1230 Avenue of the Americas
New York, New York, 10020

Designed by Patricia Walters
Manufactured in Italy

10 9 8 7 6 5 4 3 2 1

Library of Congress Cataloging in Publication data available upon request

ISBN: 0-671-75568-4

CONTENTS

ACKNOWLEDGEMENTS

The Stephen Wiltshire Trust would like to thank Fiat UK Ltd for their most generous financial assistance in Venice and for providing a motor launch which thrilled Stephen. Their thanks also extend to CIGA (The Danieli) and to British Airways.

The Trust are most grateful to Best Western Hotels and, in particular, to Aubine Zechner for arranging accommodation in Amsterdam for the Wiltshire family. Amro Bank must also be thanked for their support.

Thomson Holidays' sponsorship of the Moscow/Leningrad trip was greatly appreciated and special thanks to Liz Rabson for her unfailing good humour and devotion to this project. The Trust would also like to extend their gratitude to Blanche La Guma of APN Picture Library for providing photographs of Moscow and Leningrad in advance.

C.W. Edding (UK) Ltd provided the artist with pens, in particular the edding 1800 profipen which was used in all but one of the drawings illustrated, and which has proved invaluable.

McDonald's Restaurants of Canada Ltd provided hamburgers in Moscow and Leningrad and our special thanks to George A. Cohon for arranging this essential aspect of the artist's life.

The Trust also thanks Sir Hugh Casson for his unwavering support, Kate Trevelyan for her helpful Moscow advice, and Ron Freeman who came to the rescue when certain avenues appeared to be closed.

The black and white photograph of Stephen Wiltshire in Fred Kolman's studio is reproduced by kind permission of Paul Penning, and the aerial photograph of the Kremlin is reproduced by kind permission of Novosti Press Agency. The colour photographs in the text are by Margaret Hewson apart from that on page 10 which is by Jaqi Clayton.

FOREWORD
by Oliver Sacks

I first met Stephen Wiltshire, briefly, in 1988 when he was visiting and drawing New York. I found him somewhat 'strange', clearly autistic, but a charming and friendly boy with a wonderful gift for drawing. He did a sketch of my house, recording it perfectly, after having looked at it, it seemed to me, for no more than an instant.

But this was only a glimpse, and a tantalising one – I could see the end-product, the beautiful drawing, but had no idea of Stephen's perceptual and mental processes, how his mind worked, how he 'saw' things, how he saw the world. Nor had I more than a slight sense of him as a *person* – his tastes, his interests, his sensibilities and, above all, his capacities for emotion and for relationship with other people. I was particularly eager to learn more here, for it is these very human qualities which are said to be defective in autism: the autistic are seen, classically, as being intensely alone, incapable of relationship with others, incapable of perceiving others' feelings or perspectives, incapable of humour, playfulness, spontaneity, creativity – mere 'intelligent automata', in Asperger's terms. I was bothered by this, for even my brief glimpse of Stephen had given me a much warmer impression.

An opportunity to see more of Stephen arose when I decided to join him on his trip to Russia in the spring of 1990. In London, before we set out for Moscow, I went over Stephen in detail, 'scientifically', using some special tests for autism. This clarified much about Stephen and his approach to the world (at least his approach to the 'problems' which psychologists devise), but left me fundamentally unsatisfied – for there is a world of difference between tests and real life.

My first notes on the trip, scrawled with some difficulty in the plane (whose tossing, however, did not discommode Stephen at all) sounded a note of uncertainty, even alarm: 'Flying to Moscow, high above the gulf of Riga, Stephen is completely oblivious to his environment. He has a picture-postcard of Balmoral Castle in front of him and, completely absorbed, is doing one of his incredible drawings. I do not know whether to cry or admire: his complete indifferentness and inattention to the world (does he even feel there is 'a world'?) or his miraculous, genius-like concentration.'

But my fears were quite unfounded. Stephen was fascinated by Moscow airport – especially by the customs men in their green Soviet uniforms, and the Zil and Volga cars (which he recognised at once from pictures, but had never seen before), and as we drove into the city, he looked at the birches, the vast moonlit landscape, with

delight, his nose pressed against the cold window of the bus. The hotel, with its police presence and rigid official atmosphere, was obviously rather frightening for him: he kept close to Margaret, became silent, retracted into himself, but observed.

But we woke the next morning to a glorious day: the sun was shining in a blue, cloudless sky, Stephen had slept well, was feeling reassured. 'Hello, Oliver!' he boomed at me when he came down to breakfast, in such an open, friendly fashion I felt warmed – and astonished. How different this was from the constraint I had seen, or the sort of social automatism he had been taught, knew by heart, but did not feel. Here was a genuine, open, unrehearsed greeting; a turning to another person, of a sort the autistic, supposedly, do not show. This exuberant 'Hello, Oliver!' excited me, intrigued me, raised my hopes. I knew that Stephen was a prodigy; but now, I suddenly thought, there is a person there as well – a real person, a friendly one, not like an automaton at all.

After breakfast we wandered out towards Red Square; it was a heavenly morning, clear, cool and cloudless – a rare, perfect spring day. Everyone seemed cheerier on a day like this, though the feeling of crisis, of feared chaos, was obvious beneath. Stephen himself was actively curious, taking photographs, peering, struck by all the novelty; and he himself aroused curiosity – people turned round to look at him in the street; they had hardly ever seen a black person before. Or perhaps, in addition, it was something about *him*: his detachment, his remoteness, his odd tics – then his warm smile. He is very ready to smile if people smile at him first.

Arriving at Red Square, Stephen's eye was immediately drawn to St Basil's. 'Onion domes!' he exclaimed, smacking his lips, and started to chortle to himself. He often does this when he is happy – a wordless chortling, or sometimes singing (he knows all the current rock hits by heart, and imitates them, aloud or *sotto voce*, to perfection). St Basil's was to become his favourite building in Moscow, his emblem for Russia. But for the moment, he decided to draw the Spaasky Tower. He wanted to draw *it*, not anything else, and he wanted to draw it from exactly *here*. Passive and submissive in so many other ways, Stephen is absolutely clear and decisive about his drawing, his viewpoints. Margaret set up his drawing stool, in front of St Basil's, just as he desired.

In the enormous expanse of Red Square, a full fifteen acres of cobbles, Stephen looked both minute and remarkable, a tiny figure, sitting on a tiny stool, utterly alone, drawing, wearing a fur cap and childish navy-blue woollen mittens. A few tourists stopped and peered desultorily: they saw a funny little boy, on a little stool, pretending to draw . . . and then, as the Spaasky Tower began to take shape, as Stephen's masterly draughtsmanship and grasp of perspective became manifest, as the first outline was filled with rich, confident detail, they ceased to be desultory, they were arrested, they stopped in wonder – until finally there was a crowd of people, hushed, watching him in awe. Stephen ignored them, or was unconscious of them, and drew on undisturbed. His concentration when he is drawing is absolute: it is virtually impossible to distract him.

We left after an hour, although the drawing was incomplete; Stephen would complete it, from memory, later (it makes no difference to him, apparently, whether he draws from life, or five minutes, or five hours, or five weeks or years later – his powers of perception, his imagery, his memory, are one and the same, impervious,

apparently, to the passage of time). But a cold wind was blowing, we were all getting chilled; it was time to go back for a hot chocolate at the hotel.

As we returned, Margaret pointed out another building, one facing St Basil's on Red Square. 'That's the History Museum', she said to Stephen. 'Have a jolly good look at it. Study it. Take in the vocabulary. I want you to draw it from memory afterwards . . . Do you like it?' Stephen said, 'It's all right,' which means he didn't.

But when we got back to the hotel, and hot chocolate, Stephen drew a building with no resemblance to the History Museum; indeed, he said, 'This is *not* the History Museum,' but what it is he could not or would not say. It was a lovely building, gothic beneath, but with half a dozen onion domes above – a building composed, apparently, entirely in Stephen's mind. His aversion to the History Museum had expressed itself comically, and creatively, in this imaginary building, with a faint gothic echo of it, but adorned with his favourite onion domes. Stephen loved, was in love with, onion domes at that moment – I even thought he might put a couple on the Spaasky gate; but that was a serious drawing, a drawing for publication, and so could not have anything imaginary added. But this was a playful building, a fun building, and he was able to draw what he liked.

I had hardly seen Stephen's memory drawings before, and wondered, for a moment, whether his much-vaunted memory was defective, whether in actuality he had forgotten what the History Museum looked like. 'Draw St Basil's, you loved that,' I suggested – and now, very swiftly, singing to himself, without the minute, almost obsessional exactitude with which he had drawn the Spaasky Tower, Stephen did a delicious sketch of St Basil's: light, charming, nonchalant, altogether exquisite.

It was at this point that I suddenly stopped seeing him as a 'prodigy', and saw him as an artist through and through. Immense powers of perceiving detail, of spatial sense, of draughtsmanship, of memory, had gone into his lordly drawing of the Spaasky Tower. But St Basil's dashed off – he did the sketch in a matter of seconds – this was pure joy, playfulness, aesthetic delight, art. And above all, very human art, personal, and quite the equal of his massive, 'autistic' art.

And so our week in Russia started – a week full of work and beautiful drawings for Stephen, but equally, full of a shy and very human 'coming out' and emergence.

It is difficult to know how Stephen's art and life, now, will develop. His second book, *Cities*, compared to his first, shows a clear increase in the range and depth of his art; and this book shows how it has increased still more. I have an inkling – for he has displayed an interest in this – that he may do a fourth book on ancient cities, or lost cities, with ruins and reconstructions of Rome and Macchu Picu.

It should not be imagined, for a moment, that Stephen's perceptions or art are confined to buildings. His first drawings, as a child, were of animals, and these would make a delightful subject. When I saw Stephen in 1989, I gave him a rosebud on a branch, and he did a quite lovely drawing of this. And right from the start, since his 'wickedly clever' caricatures when he was seven, Stephen has enjoyed portraying people, either 'straight', or commonly in amiable cartoons.

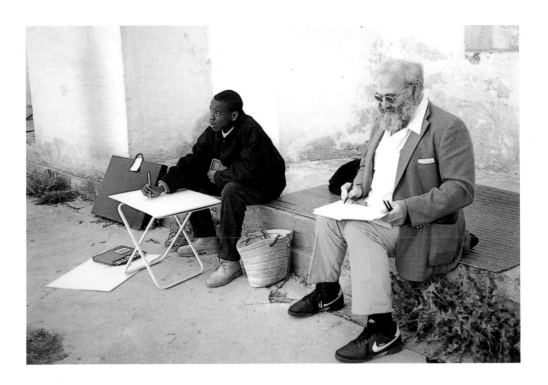

What remains uncertain is how *much* Stephen's art can, if need be, change in character; whether it can not only develop technically, but become charged with moral and human depth. And this depends, clearly, on Stephen's human development – on how much he can develop as a genuine human being, despite being (as he will always be) an autistic person.

Stephen remains, and (one fears) will always be, incapable of independent existence, and in need of special understanding, support, care; yet, given this, and given the continued encouragement of his mother, his teachers, his supporters, and (not least) his public, we may hope to see a very real and exciting further development, both as an artist and a human being.

Oliver Sacks

INTRODUCTION
by Margaret Hewson

In February 1987 Stephen Wiltshire, then aged twelve, was brought to the attention of the public in a BBC QED documentary entitled 'The Foolish Wise Ones'. The response to the programme was overwhelming because here was an autistic child whose verbal skills were negligible, who did not appear to relate to other human beings and yet who possessed a remarkable visual memory for buildings and cities which he reproduced on the programme with the consummate skill and confidence of a truly gifted artist. Stephen was described by Sir Hugh Casson as 'possibly the best child artist in Britain'.

Autism implies both perceptual and language problems. Repetitive, stereotyped, inflexible use of words, immediate and delayed echolalia (repetition of others' speech), confused grammatical structures, these are all apparent in Stephen together with an unusual response to sounds. His reaction to particular visual stimuli (buildings in the process of demolition, for example) is one of hypnotic fascination verging on the obsessive. He is innumerate but will always illustrate the correct number of columns, arcades or windows of a building. Stephen possesses his own form of secret shorthand which is not decipherable to anyone other than himself and he uses this when he is sketching a building prior to executing a detailed pen-and-ink drawing.

His mental impairment was diagnosed when he was about three years old, and the anger and frustration of the child manifested itself in tantrums and uncontrollable screaming fits. But Stephen was extremely fortunate because not only did he have the support of a mother and sister but he attended Queensmill, a school in London for children with special needs, whose remarkable headmistress, Lorraine Cole, together with a wonderfully supportive staff, were responsible for changing Stephen's life.

The imagination, the empathy and the positive nature of Lorraine Cole's vision cannot be underestimated. Here was someone who refused to patronise Stephen, who refused to relegate him to a life for the disabled but, instead, met the challenge by embarking on an educational course that taught Stephen to read and write and to exploit his one outstanding talent, his drawing. With the help of Chris Marris, the art teacher at the school, Stephen was taken round London on school trips that served to stimulate his visual appreciation. Stephen would appoint himself tour guide on the school bus, naming the familiar landmarks as they drove past and then drawing them from memory on his return to school.

The timely arrival of the BBC documentary in Stephen's life transformed his world. The BBC producer/director Tony Edwards brought public attention to an affliction which, through lack of scientific knowledge and lack of imagination, is too often ignored. By highlighting Stephen's disabilities, together with his

remarkable creative artistic talents, Tony Edwards enabled the public to think and to respond. His sensitive handling of this disabled child succeeded in conveying the miraculous abilities within Stephen.

The programme triggered a chain of events in Stephen's life which otherwise would have been inconceivable. Joan Thirkettle of ITN News took Stephen and his sister Deirdre to New York, accompanied by Chris Marris. Stephen had never travelled abroad before and the soaring verticality of New York appealed to him enormously. New York has become Stephen's spiritual home and America represents for him a dream without end. Later London City Airways and Trust House Forte financed a trip to Paris to enable Stephen to see and draw Parisian landmarks.

The importance of travel as an opportunity to widen Stephen's knowledge is inestimable. It has given him a self-assurance that is truly momentous. His verbal skills have made genuine progress and he is no longer the child who was locked into a very private world; he has become increasingly confident and playful. At home, he has fulfilled many drawing commissions for both private individuals and companies.

Stephen loves to sing and enjoys listening to pop music. He sings perfectly in tune and gives an excellent performance of whatever one requests. His version of Tom Jones singing 'It's not unusual to be loved' is hugely enjoyable. His preferred diet would be the despair of the nutritionist: chicken and chips, hamburger, turkey burger and chips, ice cream, cola and hot chocolate. Vegetables are ignored, as is fruit. A remarkable difference in Stephen's energy is immediately noticeable after his sugar level has been raised, and his stamina and energy would defeat most people. Stephen is obsessed with three things in this order: cars (preferably American Cadillacs), earthquakes and buildings. His knowledge of automobiles is extensive as is his history of earthquakes in the twentieth century. His fascination with earthquakes began at Queensmill School when he was shown a book of photographs on the subject. Since then, he has watched the video of *Earthquake* four times and follows all news items relating to earth tremors with immense enjoyment. It is interesting to note that he is terrified by thunder and has no desire to witness an earthquake although he loves watching what he terms 'devastation and destruction'. He also finds aerial views compelling.

Conversation is factual although he responds enthusiastically to nonsense. His hearing is extremely acute but he is selective in what he chooses to hear. It is possible to discuss the concrete but abstract concepts do not appear to exist for him. His humour manifests itself in his caricatures of people. Stephen divides the world into the 'gorgeous' and the 'ugly'. The cartoons in this book represent a significant development in Stephen's social awareness together with a reminder that his autism does not preclude a witty, playful nature.

Stephen's drawing skills fall into a number of categories. He is able to look at a building for a few minutes and reproduce it from memory (*see* The British Embassy in Moscow on page 106). He will produce a detailed drawing from a photograph (*see* the Aerial View of the Kremlin on page 89) and he can draw imaginative cities, landscapes or buildings (*see* 'This Is *Not* The History Museum' on page 93). He will also draw in the front of a building, on site, sometimes in pencil first and complete the drawing later in pen; or, best of all perhaps, he will work straight into pen with no prior pencil sketch (see the Rialto Bridge on page 23).

* * *

The idea for this book was conceived in a truly spontaneous manner. One evening in October 1989, my husband Andrew and I were discussing the possibility of spending Christmas in Venice with our daughter. It is the perfect time to see this hauntingly beautiful, sad yet unbearably seductive city when it is devoid of tourists and the winter sun serves to dramatise and intensify the splendours of a by-gone republic. For a long time, I had dreamed of Stephen recording his visual impressions of Venice on paper. It was a fantasy, part of a recurring sub-conscious desire to show him what I considered to be the most alluring of cities. Suddenly I knew that he must come with us and, without further reflection, telephoned his home to suggest that he and his sister accompany us on this family holiday. The response was ecstatic. It would be arranged immediately.

On recovering from the idea of Stephen in Venice, I went into my office the following day and realised the problems that now asserted themselves. First, we would have to stay at the Danieli because the unique panorama of the lagoon would not be possible to execute from any other location. Second, if it snowed or rained, we should be forced to draw interiors and Stephen had never attempted this. To resolve the initial dilemma, Fiat UK Ltd, whose astounding generosity removed the financial worries of this trip, gave us the opportunity to introduce Stephen to the magic of Venice, and CIGA, who own the Danieli, offered rooms for Stephen and his sister. The interior of St Stephen's Walbrook in London was chosen to overcome the second obstacle of this projected trip. If Stephen could capture the complexity of the spatial dynamics of this Wren interior and achieve the clarity of its expression, then Venetian interiors would present no problem. The chairman of the Arts Council, Peter Palumbo, was approached to commission this interior, and when informed that it could prove a disastrous

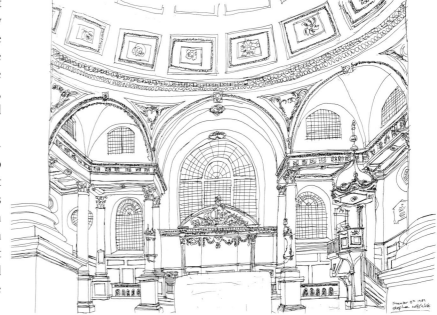

venture, stated: 'One must always allow the artist the right to fail.' Brave, empathetic words which resounded in my head as I left the meeting. Stephen's drawing of the church's interior surpassed all my expectations and Venice became a reality. The BBC were informed and the producer of the initial QED programme, Tony Edwards, agreed to make a follow-up documentary which would illustrate Stephen's development during these three years.

The Venetian drawings in this book speak for themselves and represent Stephen's very personal response to the buildings he was asked to draw. It is difficult to prevent the development of an idea because it appears to have its own momentum. Venice led to thoughts of northern Europe by way of contrast – Amsterdam's Golden Age in juxtaposition to a southern refinement. Then, why not 'floating cities' to include Leningrad? The concept had materialised and we decided to embark on an enterprise that would record Venice, Amsterdam and Leningrad.

Best Western Hotels promptly came to our aid by providing accommodation for the entire Wiltshire family in Amsterdam. Stephen's ex-head mistress, Lorraine Cole, accompanied us on this trip, and together we shared the experience of seeing Stephen in Amsterdam. Andrew and I spent the first two days with him, leaving Lorraine Cole to supervise the following three days. The Amsterdam drawings reflect Stephen's five days in this city and their authentic tone mirrors the solid confidence of this burgher town.

Each foreign trip requires considerable research as the time available on arrival at our destination is limited. The knowledge I acquired as a result of Stephen's response to Venice and Amsterdam led me to believe that we could not omit Moscow from the Russian excursion. It requires a singular act of the imagination to conceive of Moscow as a 'floating city' and no amount of sophistry will convince the reader. Quite simply, it seemed to me that Leningrad could not fully demonstrate Stephen's astounding artistic talent. Moscow, on the other hand, possesses that fusion of Byzantine and Italian baroque in characteristic Russian style which Stephen loves. The petrified grandiloquence of the Kremlin had to be included in this Russian adventure. The publishers were informed of this further development and Moscow was added as the final afterthought. The omission of Moscow in the title of the book is thus explained.

Thomson Holidays provided the funding for Stephen, my colleague Jaqi and myself to enable us to go to Moscow and Leningrad. Dr Oliver Sacks, the eminent neurologist, accompanied us together with the BBC producer/director Tony Edwards. We spent four days in Moscow and three in Leningrad. Intourist provided a bus which was at Stephen's disposal whenever we chose to use it and an interpreter who was constantly available. Intourist also gave us VIP status for which I was most grateful. This preferential treatment allowed us to work quickly and efficiently and accounts for the large number of drawings which Stephen was able to execute. McDonald's in Moscow allowed us to slip through the side entrance to the restaurant each day for lunch and provided the buns for hamburgers in Leningrad.

I chose all the buildings Stephen would draw in the four cities visited except where otherwise stated. The selection is entirely subjective and is dictated by my own very personal whims and prejudices. To me, the choice manifests the different sensibility of each city and Stephen's supreme artistry always captures the right spirit.

Some of the drawings executed from photographs prior to our various trips illustrate views which would not otherwise have been possible. The aerial view of the Kremlin would have required a helicopter, and the drawing of Palace Square in Leningrad would have necessitated a crane to place Stephen on top of the Triumphal Arch. The bascule bridge in Leningrad never opened while we were there but Stephen's drawing from a photograph dramatically portrays what few visitors will ever see. Photographs also enable me to teach Stephen the architectural vocabulary of buildings.

The generosity of sponsors, wonderful weather and an enthusiastic artist all combined to produce this unique autistic child's record of four extraordinary cities.

Margaret Hewson

VENICE

MIKE MEDAVOY
*(Chairman of Tri-Star
Pictures)*: 'Stephen, what do you think of Venice?'

STEPHEN: 'I like Chicago.'

Anna and me in venice.

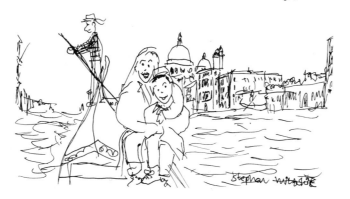

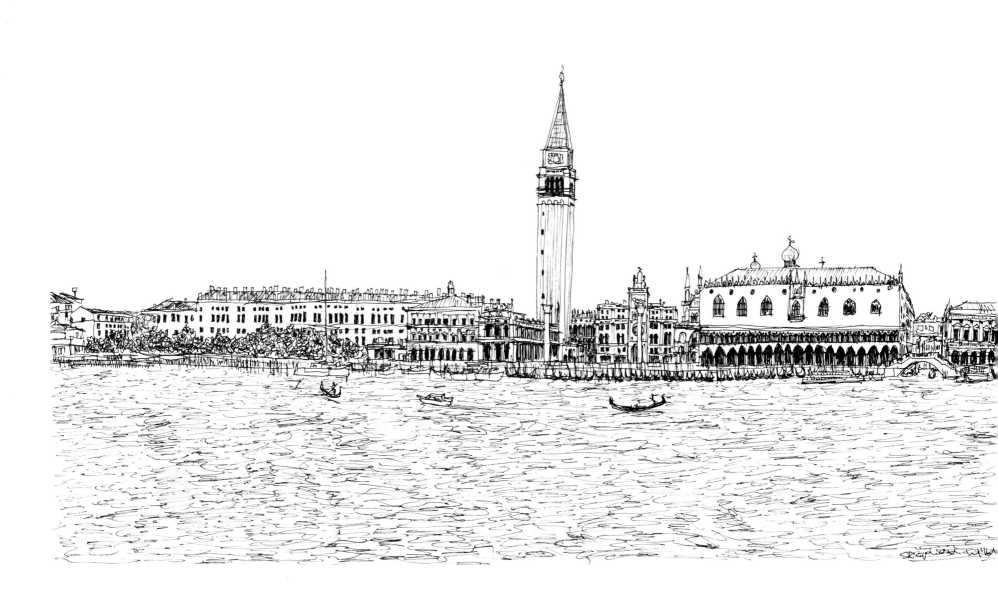

VIEW FROM SAN GIORGIO MAGGIORE

It is the morning of 1 January 1990 and we are seated in the forecourt of San Giorgio Maggiore. The gondolas are moored because most Venetians are still in bed. I ask Stephen to draw the view from the Doges' Palace to the Salute. 'I'll see,' he says. The profundity of Stephen's laconic statements frequently baffles me but, forty-five minutes later, I do 'see': Stephen begins with the Bridge of Sighs in pencil (a much better balanced composition than my own suggestion) and works his way from right to left until he arrives at the edge of the paper. Of course *he* knew that the Salute could not be incorporated in this drawing on A2 paper because it lacks the necessary width, but his impeccable manners prevented him from stating this.

The two gondoliers are both figments of Stephen's imagination. He loves drawing them and they appear when he is amused.

On our return to the hotel, this drawing is completed in pen. As usual, the incredible detail, which the pencil sketch does not illustrate, is revealed when he takes up his pen. The pencil sketch outlines the buildings but his memory serves to complete the intricate detail in pen.

Stephen has just completed the pencil sketch of the view from San Giorgio looking back to St. Mark's. We are waiting for our launch to return us to the hotel to pen the drawing, and Stephen scribbles this doorway while we wait.

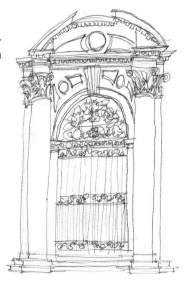

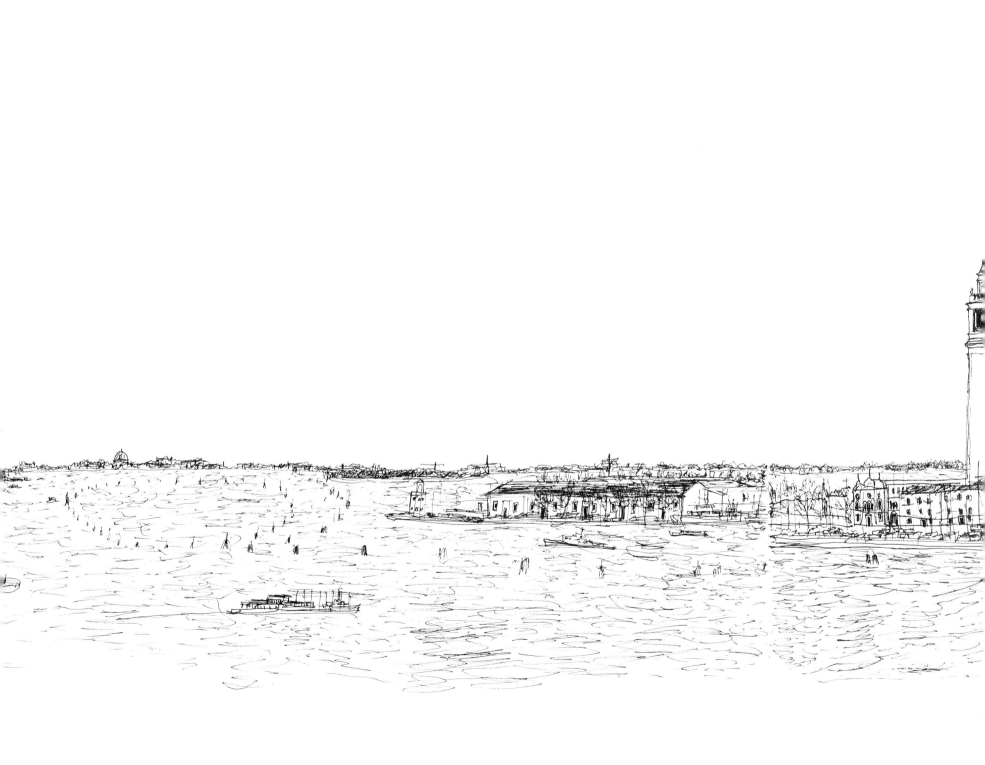

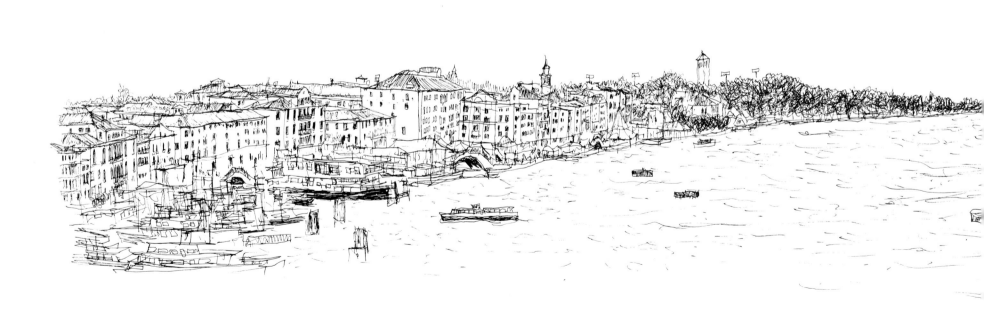

PANORAMA OF THE LAGOON

This unique 180° panorama of the lagoon as seen from the restaurant terrace of the Danieli hotel is drawn by Stephen over a five-day period. After breakfast each day, a long dining-table is set up on the terrace with the help of the accommodating waiters who hail Stephen as 'the reincarnation of Canaletto'. The panorama is in three sections and begins on the left-hand side, continues on a second sheet with San Giorgio to the bridge before Il Redentore and finishes on the final sheet of paper with the Salute.

Stephen is well wrapped up and wears gloves as he draws – in Venice he always wears woollen gloves when is he drawing outside.

On the first morning, the paper is secured to the table with two bulldog clips and as the roll does not extend the full length of the table, we pile books on the other end.

Stephen starts with the buildings in the far left-hand corner and draws with alarming speed the view as seen from the roof-top terrace of the hotel. As usual, it is impossible for the bystander to discern the detail which Stephen himself sees but his pen marks the horizontal to the vertical, the character and the perspective. In the distance, the Lido can just be seen. The buoys which mark the channels to the Lido are drawn because Stephen is fascinated by the traffic in the lagoon. His visual perception, when applied to grand views, defies analysis. It is simply astonishing that a human eye can anatomise these buildings and the waterfront with such authority and authenticity.

The second roll of paper is attached having been perfectly matched to join the first roll. The BBC film Stephen drawing San Giorgio which is enveloped in mist – the only mist we are to experience during the trip. Stephen continues to draw despite the poor visibility, popping a window into the dome which a BBC crew member suggests is not there. As the mist rises, every detail on Stephen's drawing reveals his visual accuracy – including the window.

The two curious lines halfway through the middle section are drawn when visibility is practically nil. I have no idea what Stephen intends by these lines and am reluctant to ask because there is clearly a purpose which will presumably reveal itself. The following day, all is explained as Stephen scribbles over the two lines to suggest the landscape on the horizon behind San Giorgio but then announces, 'Margaret, I have made a mistake,' and puts down his pen. The two lines, drawn the previous day, were to form part of the horizon landscape but in today's full sun, this landscape beyond the

Guidecca does not exist although the lines are correct for the horizon landscape behind San Giorgio. Stephen has never articulated his mistakes in the past. On previous occasions, we have abandoned drawings because he would look at me, put down his pen, smile and shake his head. The reason for this utterance now is that Stephen knows that the panorama is excellent so far and he does not wish to discard it but he doesn't know what to do with these two lines. I tell him to ignore them and carry on with the Guidecca.

As Stephen draws, he sings Fergal Sharkey's 'A good heart these days is hard to find so please be gentle.' As he is being treated like Louis XIV, the words are hilariously inappropriate. This is followed by a rendering of Mel Smith's 'Deck the house with thousand folly, fa la la lalala', which Stephen assures me are the correct words although he frequently jumbles sounds which he hears. I was never able to teach him to say 'San Giorgio Maggiore'. My daughter Anna and Stephen then sing the Marmite advertisement together, interspersed by snatches of 'I'm an excellent driver' from Stephen (words from the *Rain Man*). As he is nearing completion of the panorama, the Salute having been lovingly erected, he is giggling and gurgling to himself with pleasure. 'Margaret, shall I draw the people?' As can be seen from the other Venetian drawings, people do not appear – apart from his special *gondalieri*. This time, because Stephen is in excellent spirits and enjoying a ludicrous exchange with Anna, the people are delineated together with a Venetian dog; in fact, this does not exist but is popped in by special request from Anna.

The entire panorama has taken approximately eight hours to complete. Five consecutive days of blue skies and brilliant sunshine, and the availability of the restaurant's roof-terrace of the Danieli have made possible Stephen's most ambitious project to date. He is thrilled with the finished artwork and he and I celebrate by dancing a quickstep around the terrace to the astonishment of the startled breakfast guests.

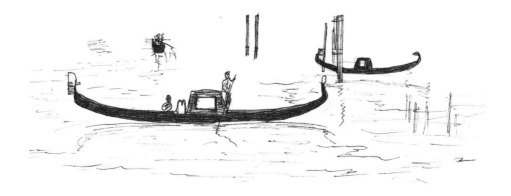

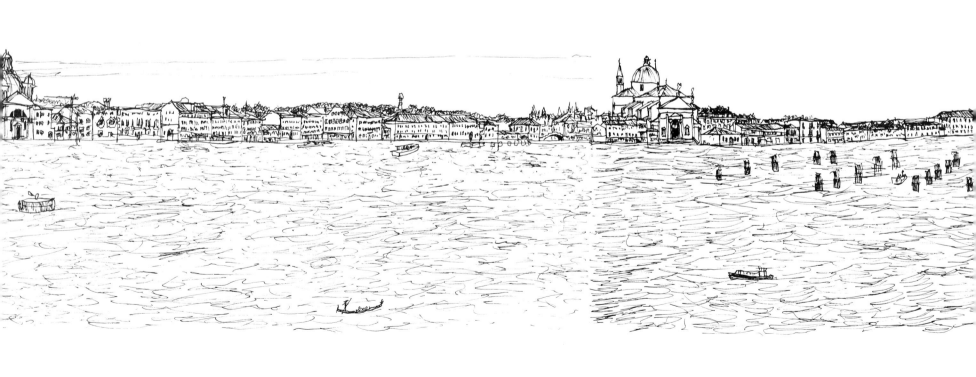

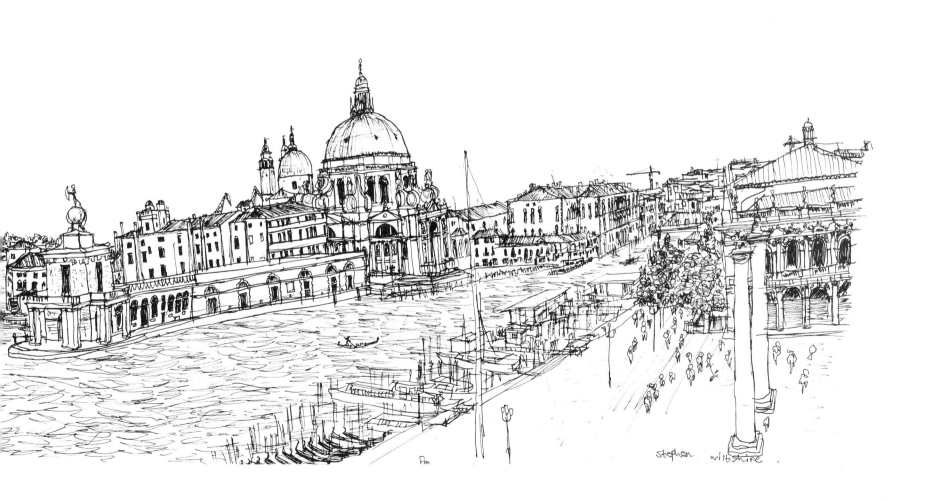

Stephen Wiltshire.

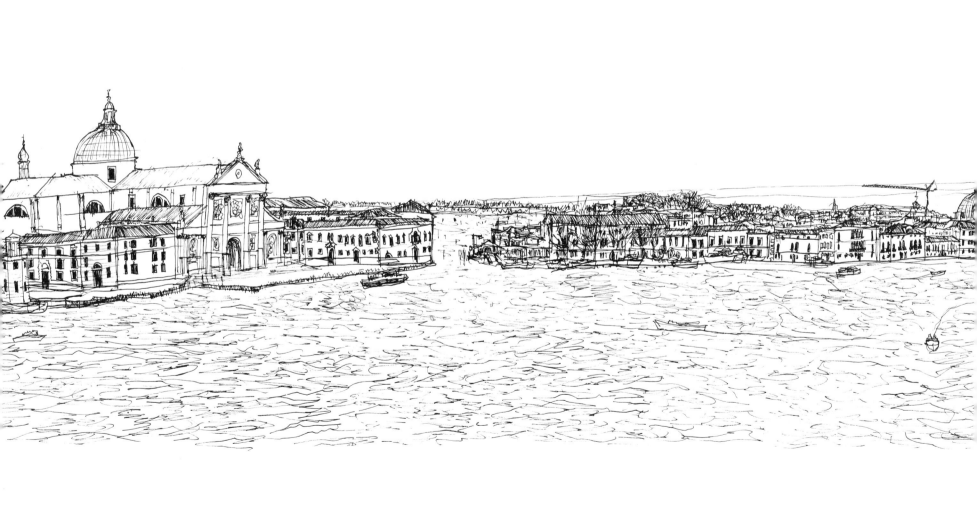

THE RIALTO

Stephen is shown two Canaletto sketches produced in pen and brown ink over pencil; the illustrations were in the 1989 Metropolitan Museum of Art's catalogue. He also is shown a large turn-of-the-century photograph of the bridge which I have bought in Portobello Market. This sketch draws on both sources and is executed prior to the Venetian trip.

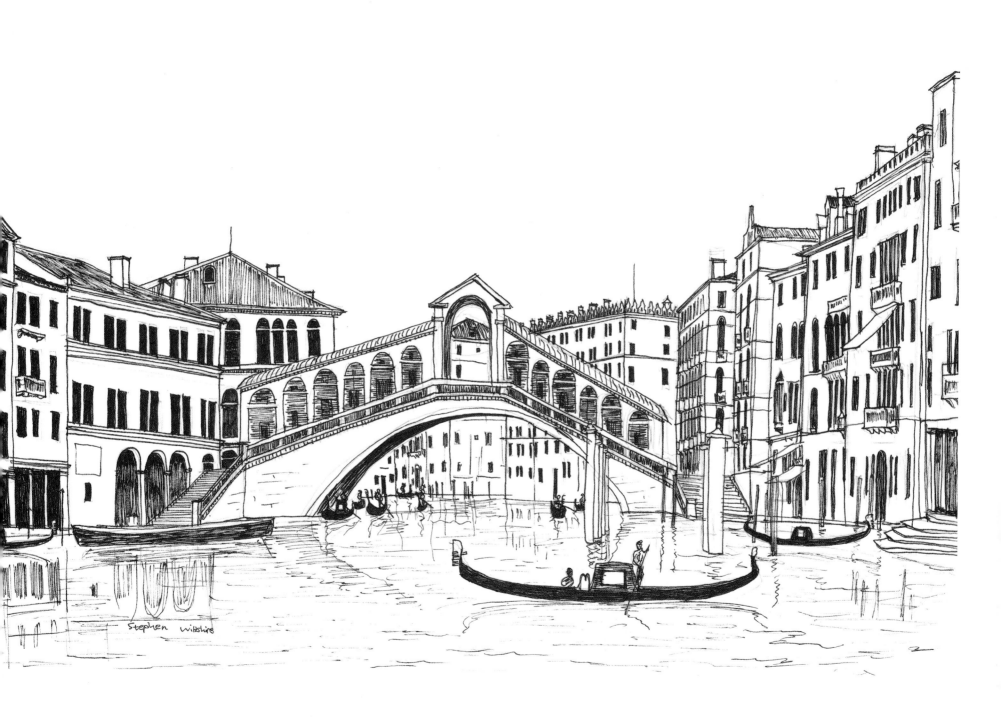

Stephen Wiltshire

THE RIALTO (2)

Stephen and I are filmed as we go from St Mark's to the Rialto in a gondola. The experience does not appeal and Stephen, who is supposed to point out the buildings he likes and to name them – something he is perfectly capable of doing – decides to adopt a studied silence. With Job-like resignation and stoicism, he endures the trip.

It is with considerable relief that he steps from the boat at the Rialto and starts to draw in pen. After a few minutes, I seat him on his travelling stool. He is smiling and humming as he pens this delightfully fresh sketch in the sunlight. The bridge is drawn first and then the buidings beneath the arch on the opposite bank are added. He is feeling extremely confident and is in no hurry to finish. The mooring posts and the water are studied and then brilliantly suggested by a few deft strokes.

Afterwards, we take photographs of Stephen and then Stephen grabs his own camera and calls to his sister, 'Deirdre, come on, I want to take your picture, come on, come on . . .' He is jumping up and down and laughing. He is supremely happy and communicating. Autistic children do not appear to relate to other human beings and Stephen is no exception. He had photographed views and buildings but never before people while we were in Venice. This is the first time that we all witness an enthusiastic little boy who wants to photograph his sister. As can be seen from the cartoon, his sister has other ideas, and refuses to be 'snapped' by her brother. The BBC crew are more successful.

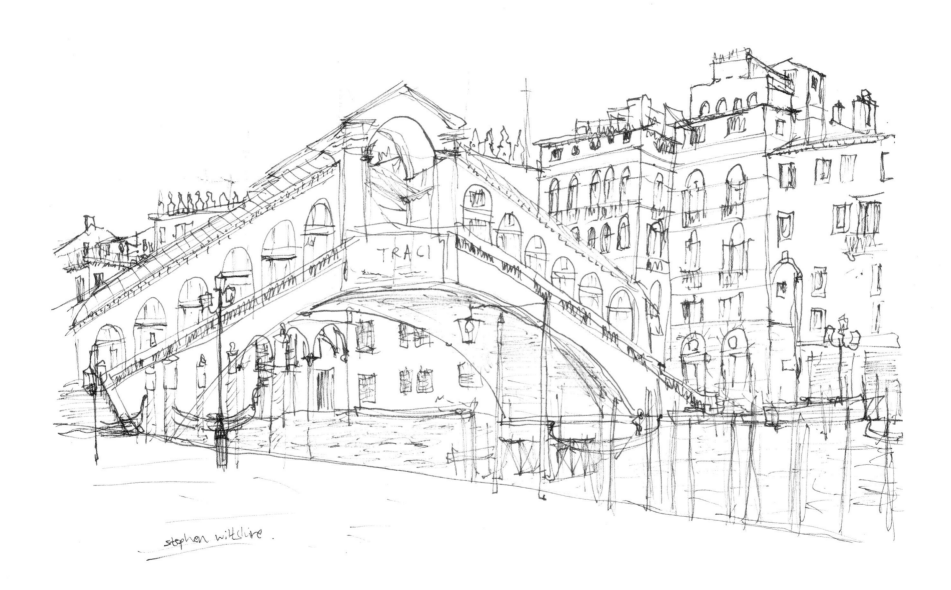

stephen wiltshire.

THE DOGES' PALACE

Stephen is seated on the water front with the water from the lagoon lapping around his feet. He is in excellent humour because the previous evening his X-ray eyes had spotted a model of a toy car in a shop which was closed. I had promised to return with him the following day. Stephen leads me to the shop from our hotel as I pretend to be blind. His unfailing sense of direction takes us both there without hesitation, the route having been memorised the previous night.

The model car safely in his possession, and the BBC ready to film, Stephen begins to draw in pen. Directly in front of his field of vision rises the monolithic column. Stephen starts with this and then, with startling speed, he skates three lines in both directions which immediately establish the Palace's perspective. The florid Gothic decoration is then filled in at each level and the quatrefoil decoration is 'scribbled' over the triforium as he laughs to himself. Passers-by photograph him, others stand immediately in front of his field of vision. Stephen is oblivious to any interference and blithely carries on drawing – but the people are omitted from the work. The overwhelming vigorous monumentality of this building which Stephen captures on paper is in sharp contrast to the majestic, stately Doges' Palace as drawn from San Giorgio on page 16. The physical intensity is conveyed because Stephen is so close to the building.

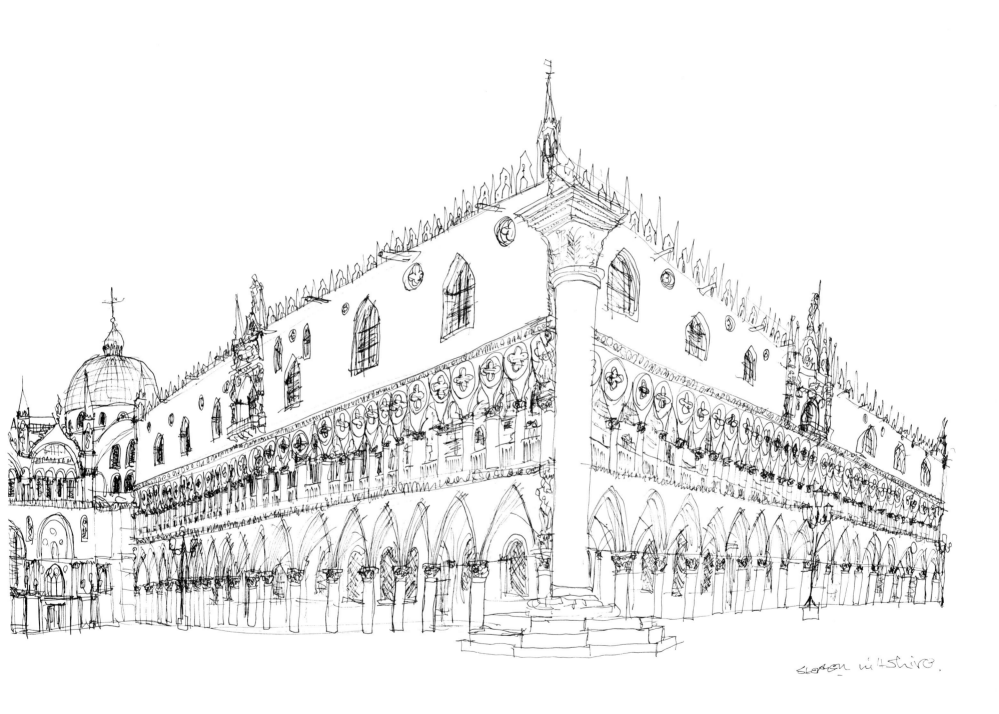

Stephen Wiltshire.

ST MARK'S

This is a pen and colour drawing of a nineteenth-century photograph, drawn before Stephen's arrival in Venice.

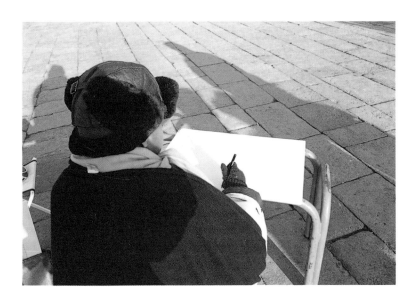

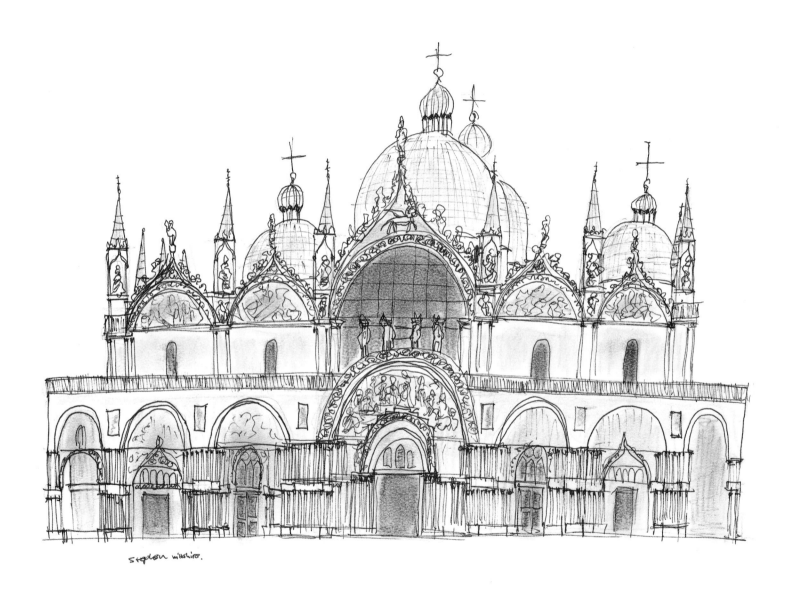

Stephen Wiltshire.

ST MARK'S (2)

It is a piercingly bright blue-skied morning and Stephen decides to sketch the cathedral in pencil. He is seated well back in the square on his travelling stool. Both sets of five arches are quickly drawn, very faintly, and the domes roughly outlined. There is scaffolding which obscures the two arches on the left of the building's front, with wooden boarding nailed to the window behind the bronze horses. I ask Stephen to ignore the scaffolding telling him that the vocabulary on the left is identical to that on the right. His pencil then draws a line from the base of the campanile upwards – although most people would draw the straight lines from the top down. The stately public buildings on either side are then sketched and the arcades suggested by pencil squiggles. Stephen's shorthand has never been so much in evidence.

It is very cold and Stephen wants to go to Florian's for hot chocolate and cakes. It is impossible to believe that this very faint, undetailed pencil sketch on A2 paper will transform itself into a detailed pen drawing one hour later back at the hotel. Stephen has not suggested in the pencil sketch that the two elevations on either side of the cathedral might be different. In the warmth of the hotel writing-room, the segmental and triangular pediments appear. Stephen had noted that both sides were different. The pencil sketch simply provides, in his own shorthand, the framework for the composition and he deciphers his squiggles (often scrutinising his pencil marks) when he takes up his pen. The detailed vocabulary has been 'logged' in his mind and recorded in pencil.

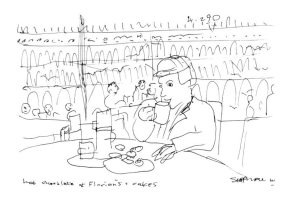

hot chocolate at Florian's + cakes

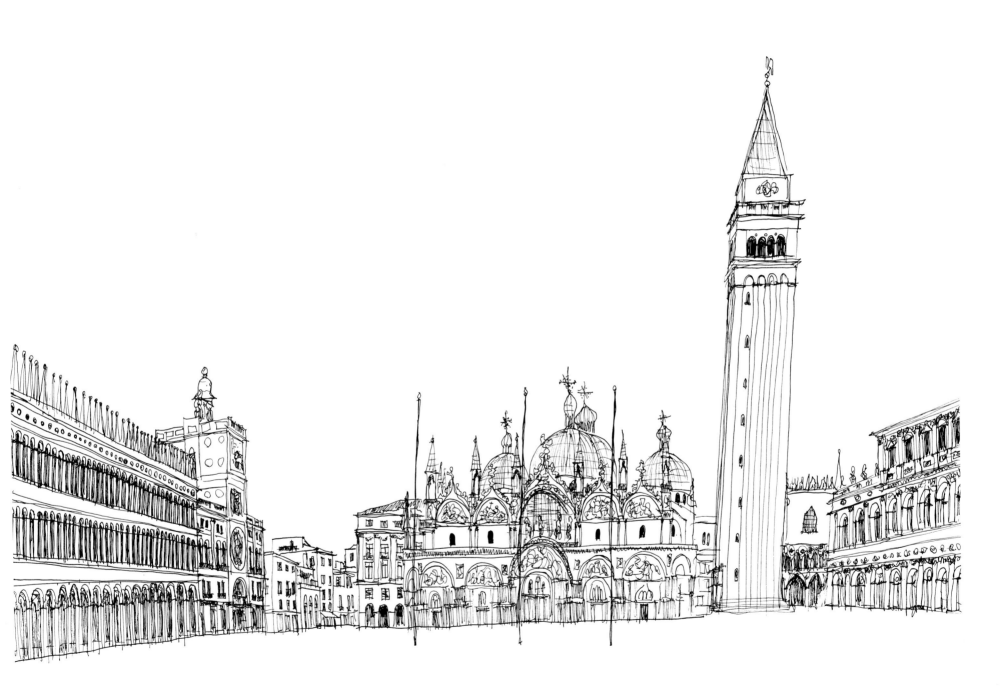

Stephen Wiltshire

CA D'ORO

This is the best surviving example of domestic Venetian Gothic architecture in Venice. I attempted to convey the sumptuous decoration and richness of Venetian vocabulary to Stephen prior to our trip by showing him an illustration of Ruskin's watercolour of the Ca d'Oro, a large nineteenth-century photograph of the building which I found in Portobello Market and a watercolour my father painted in the 1920s.

Stephen's Ca d'Oro is an imaginative drawing culled from the inspiration of the works he had been shown. He uses pencil and clearly defines the lacework tracery and enjoys the elaborate nature of the open-work screens. The ogee windows are perfectly captured and the crockets on the roof delicately suggested.

Having completed the sketch, Stephen decides to colour the drawing with crayons. Each colour is applied and then rubbed with his forefinger to prevent smudging. The canal colour is a clever use of various combinations of crayons.

Stephen is thrilled with his work and states, 'It's good.'

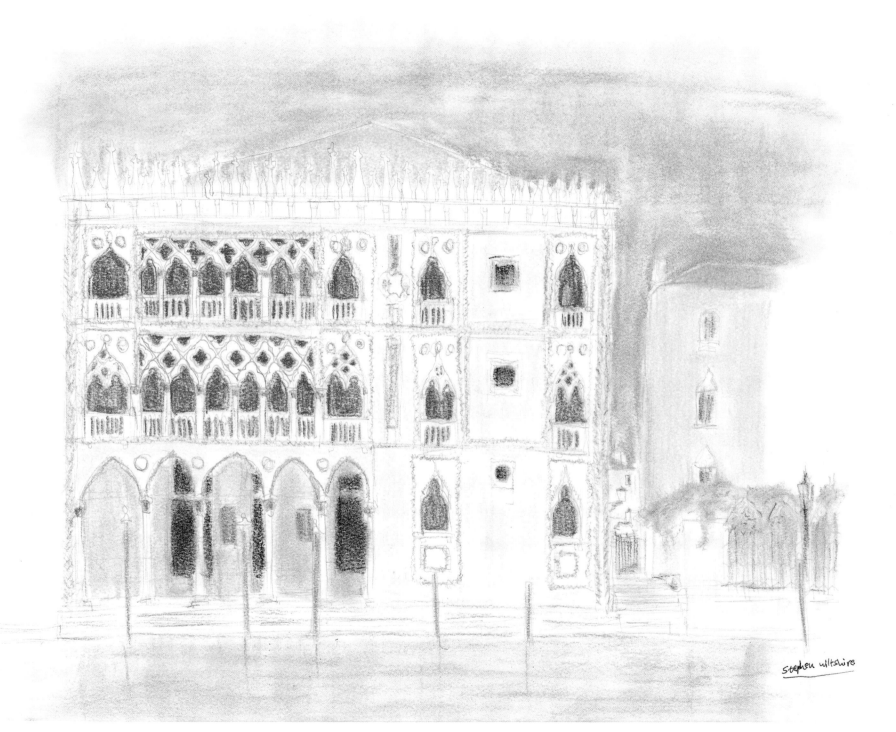

stephen wiltshire

THE BRIDGE OF SIGHS

Stephen and I take a brisk walk before dinner. It is cold and it is dark but the lights from the piazzetta illuminate the bridge. He has drawn the bridge itself in two minutes and then completes the diminishing view down the little canal. His ability to capture the perspective is astounding, especially in a lightning sketch as here.

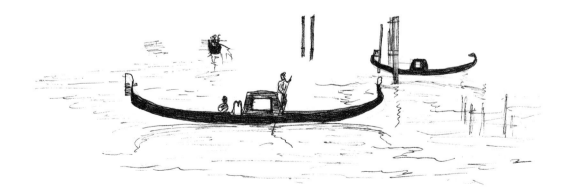

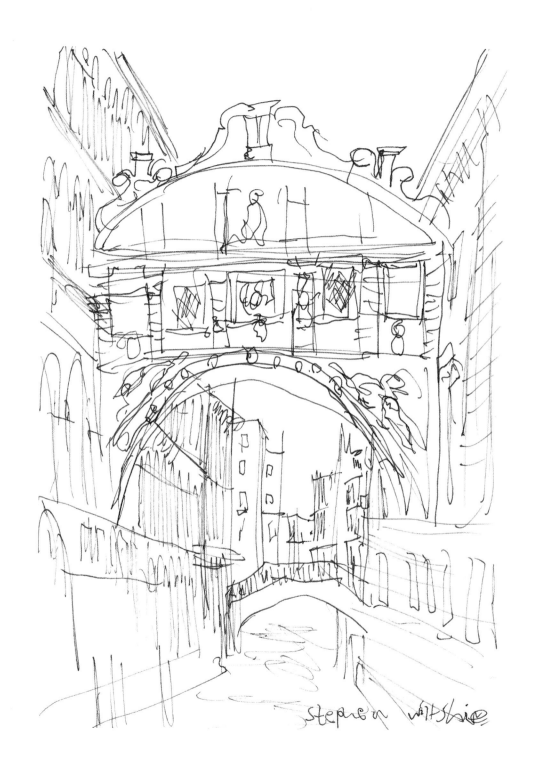
Stephen Wiltshire

THE DANIELI

This colour drawing is a present to the Danieli for their generosity in providing rooms for Stephen and his sister. It now hangs in the entrance hall of the hotel.

The uncoloured pen sketch is drawn by Stephen in the aeroplane en route to Venice. I show him a photograph of the hotel and he spends twelve minutes translating the photograph to his own pen marks.

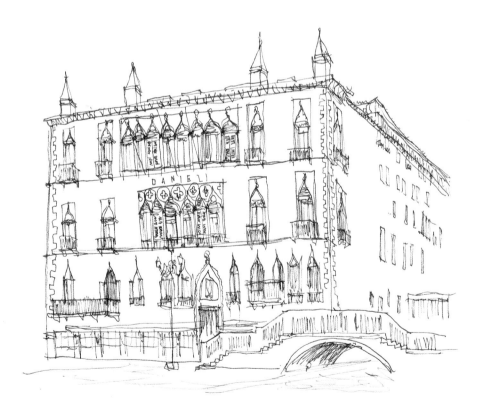

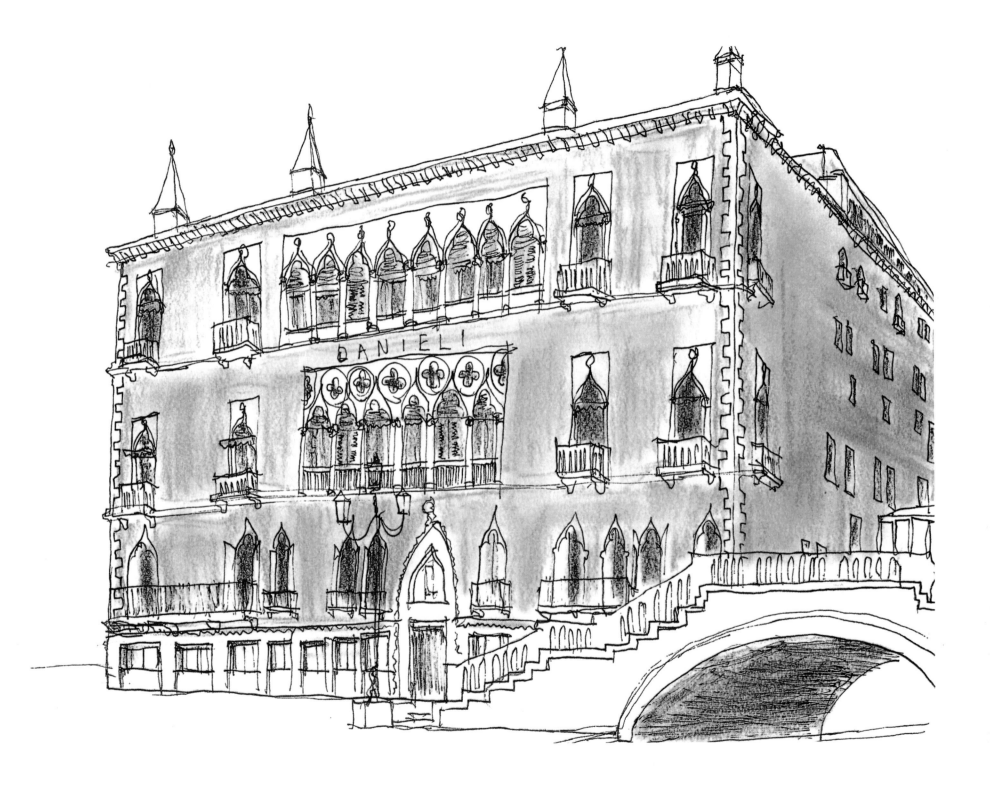

SAN MOISE

Stephen is seated in the corner of the square beside the ugly façade of the Bauer Grunwald Hotel and in front of the pretty Rio San Moise which is used as a mooring for gondolas.

Stephen's ability to suggest highly complicated, overwrought baroque façades is most impressive and San Moise is chosen for its almost neurotic intensity. The light is failing fast and it is very cold. I ask the staff of the Bauer Grunwald if they will lend me one of the many tables in their entrance hall for Stephen to balance his drawing pad. The request is refused on the grounds that several official forms would have to be completed in order to abide by Venetian law before this simple transaction could take place. The excuse is almost as baroque as the language of San Moise itself. In anger and dismay, I flounce out of the hotel to set up our second travelling stool as a makeshift table.

Stephen takes up his pen and appears to crochet the façade with alarming speed. He begins with the central doorway and knits upwards. Two charming little French brothers, aged about nine and twelve years, come to watch, announcing, *'C'est pas mal.'* The captain of the gondola station, an artist who paints during the winter months when business is slack, informs us that, fifteen years ago, he watched an autistic man sit where Stephen is seated now, drawing scenes of Venice from memory and then selling his drawings in St Mark's Square.

Stephen Wiltshire

PALAZZO GRASSI

One of the last grand houses to be built on the Grand Canal, Palazzo Grassi is now owned by Fiat. We are collected from the Danieli by motor launch, provided by Fiat, and ask to be taken to the vaporetto landing stage opposite the Palazzo. The drawing is to be a present to the company for their generosity in funding the visit to Venice. Stephen loves the motor launch trip and takes numerous photographs as we race up the Grand Canal.

On our arrival, a problem asserts itself immediately. We require a table the right height for Stephen because this pen drawing will be executed on site. I turn round and see that we are in front of an antique shop called Crosara Giorgio. I go into the shop and the ideal table is straight in front of me: eighteenth-century, price ignored. The smiling owner emerges from a backroom and I explain my dilemma in halting Italian. He immediately removes the objects which are displayed on the table, carries it out to Stephen and suggests that my family and Stephen's sister shelter in the warmth of his shop while Stephen draws. The spontaneity of Venetian hospitality is most refreshing.

My daughter Anna sits beside Stephen as he draws and they sing the theme tune to *Rain Man* as a duet, followed by a recitation from Stephen of excerpts from Dustin Hoffman's script. Stephen adores music and loves to entertain himself by singing as he draws. Both he and Anna laugh so much at their performance that Stephen loses concentration and incorrectly counts the arcades beside the quaint Byzantine campanile of San Samuele. It is possible to see Stephen's correction to this on the fifth and sixth arcade window.

The drawing takes 1¾ hours to complete. All the classical features are noted and the rustication is brilliantly suggested. The buildings and pretty campanile together with a typical Stephen tree soften the magnificent austerity of the Palazzo Grassi and make the drawing sing.

VIEW FROM THE ACCADEMIA BRIDGE

Stephen and I are crossing the bridge on our way to draw another church. The light is failing and I want Stephen to hurry but he has decided to ignore me and takes photographs of the view down to Santa Maria della Salute instead. He is in a frenzy of excitement and the view is 'just right' he says. I eventually put my arm round him and, in order to distract him, suggest we race each other down the steps. It is, of course, a view much celebrated by Canaletto and Stephen photographs only what really interests him.

On our return to the hotel, I tell Stephen how much I'm looking forward to the development of his film and, in particular, the Accademia view. Would he draw it for me now? He promptly sits down at the writing-desk in my bedroom and produces this view from memory.

IMAGINARY VENICE

Stephen appears to absorb cities by a form of visual osmosis. After five days in Venice, my husband Andrew asks Stephen to draw a lightning imaginary sketch of Venice while we are in our hotel bedroom. I had spent many hours telling Stephen about the differing architectural styles. He would respond by smiling and it was difficult to ascertain whether or not he understood. When I married the language to a visual image of a buiding, we invented a game whereby I would point to a Venetian Gothic façade and he would tell me what it was. In this way, he learned to name the different styles. In response to Andrew's request, Stephen turned to me and said, 'Margaret, do you want Venetian Gothic or Rennaissance?' For a child with language difficulties, this was a real celebration and perhaps illustrates that one must never underestimate the ability of these children to assimilate knowledge just because they fail to respond to traditional learning patterns.

This witty little sketch took five minutes to draw and the ubiquitous gondoliers with their flying ribbons have now become Stephen's hallmark.

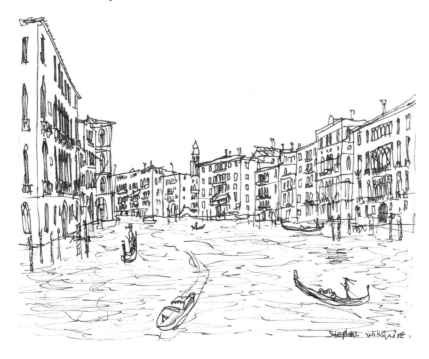

SANTA MARIA DEI MIRACOLI

This exquisite Renaissance church is breathtakingly beautiful. It is, however, difficult to draw because the position of the church in relation to the other buildings makes it impossible to find the correct site from which Stephen can read the building. The harmony, symmetry and balance of the exterior façade prove hard for him to capture where he is sitting at the left of the church. As can be seen from the drawing below the view is not 'in focus' and the distortion which Stephen captures communicates his unease at not being able to define the language correctly.

He is much happier drawing the canal elevation because the problem no longer presents itself and this tiny church is suddenly brought to its full glory on the page by Stephen's idiosyncratic pen lines.

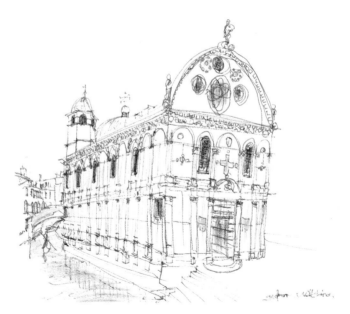

In contrast, the pencil and crayon drawing opposite was executed from a photograph before Stephen's trip to Venice.

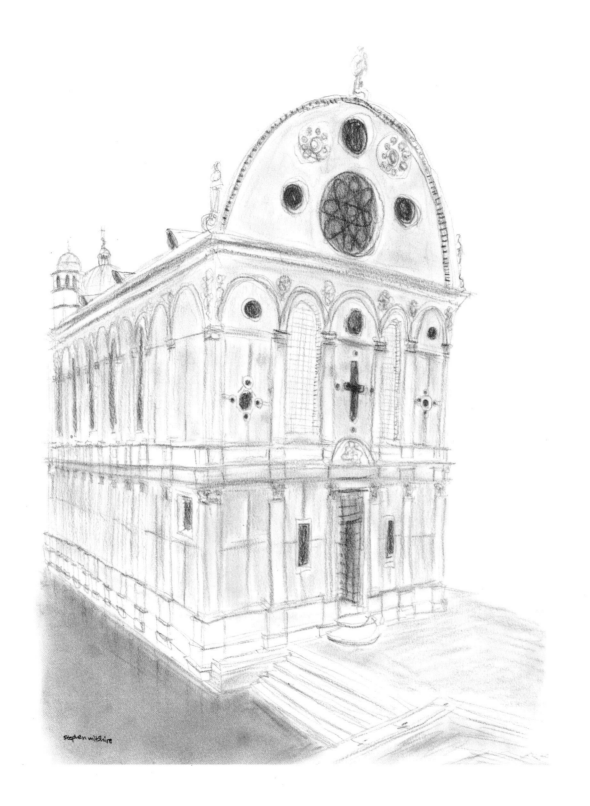

SAN GIORGIO MAGGIORE

One evening, Stephen and I walk over to the waterfront where the gondolas are moored for the night. In front of us, across the lagoon, the Palladian façade of San Giorgio is illuminated. It resembles a stage-set which has been lit as a backdrop. It is impossible to see the window in the dome and the twin towers beyond. The tall campanile is visible but the buildings to the left of the front elevation of the church are merely shapes in the darkness. The acute sensitivity of Stephen's visual perception is such that his pen notes what is invisible to the ordinary human eye. What I am seeing is little short of a miracle.

This four-minute sketch at night should be compared to the drawing of the same building executed in daylight on the next page.

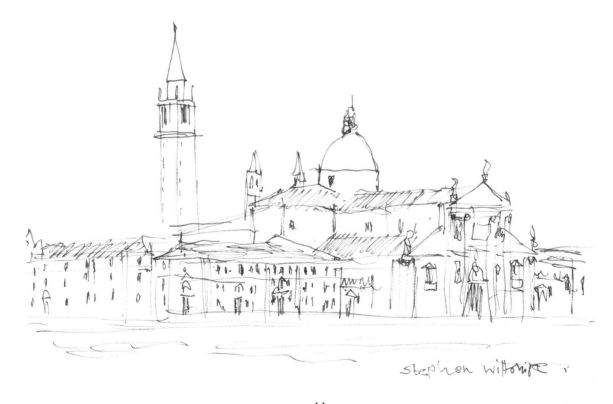

SAN GIORGIO MAGGIORE (2)

This pen sketch is filmed by the BBC over a fifteen-minute period in its entirety. Stephen's pad is balanced on the back of the BBC's film cases as an improvised easel. Halfway through the drawing, the report from the Venetian scare-gun (to keep the pigeons moving) makes Stephen jump momentarily. He is frightened by thunder and this noise disturbs him but the firm hand of the BBC director is on his shoulder. It is a measure of Stephen's self-control that he is able to continue to complete the drawing in circumstances which are not entirely advantageous. The pen strokes do not reflect his anxiety and he produces a beautifully orchestrated composition.

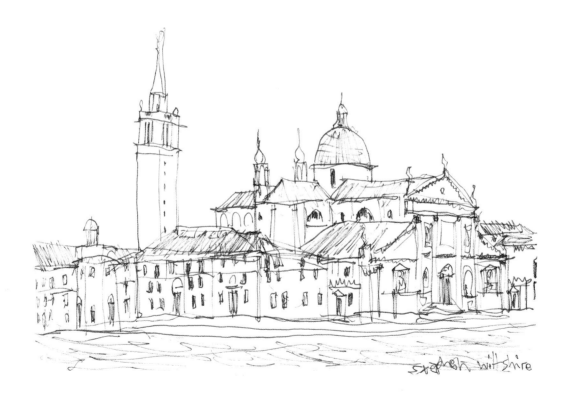

SANTA MARIA DELLA SALUTE

Stephen's favourite building in Venice is the Salute. It possesses a Venetian baroque confidence, fabulous, bold and grand, which Stephen finds most seductive. It is drawn before breakfast from the dining-room of the Danieli which commands a superlative view of the church. Because we are inside, Stephen is not wearing gloves to draw. He hums and smiles as he pens and then decides to rub in a little colour. The foreground detail of the boats is an afterthought and serves to provide a charmingly balanced composition.

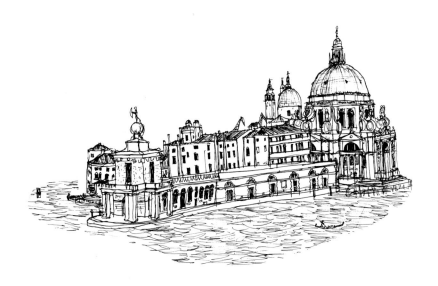

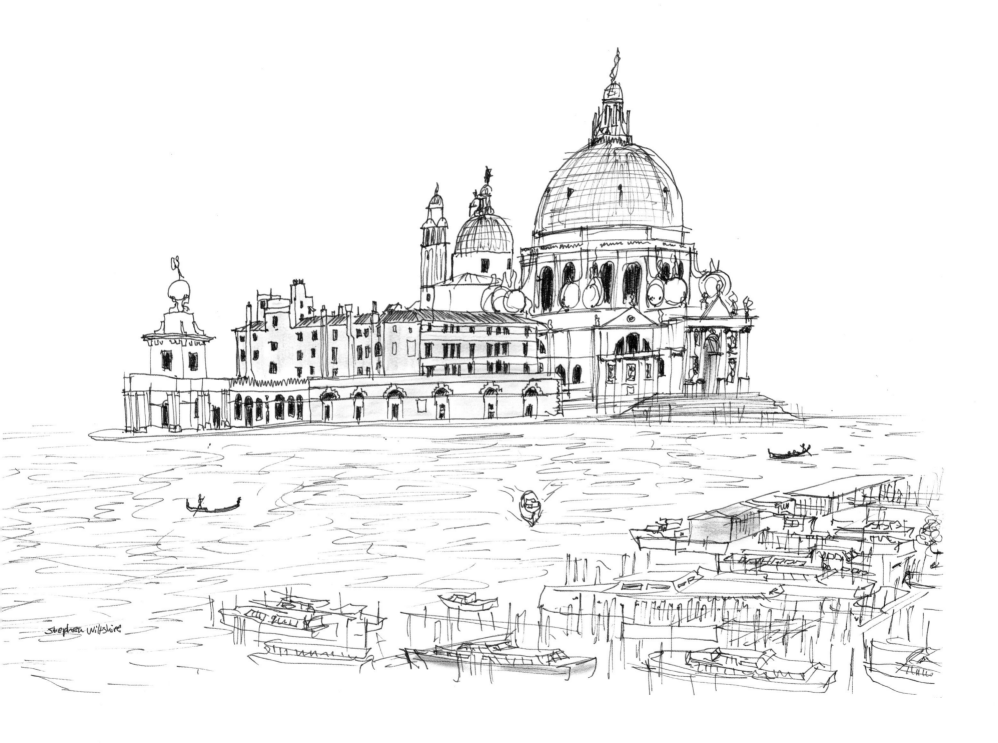

Stephen Wiltshire

SAN TROVASO – THE SQUERO

The visit to the *squero* where gondolas are repaired and built was suggested to me by Sir Hugh Casson prior to our Venetian trip. It is a charming picturesque setting, a pretty domestic scene with a wooden balcony; it is quite un-Venetian, indeed, far more Dutch. There are upturned gondolas in the foreground, notoriously difficult to draw, and a washing line with sheets and pyjamas in the background.

Stephen is filmed as he draws in pen. Each drawing takes about four minutes but the casual unfinished manner of his signature tells me that he much dislikes this exercise and clearly he feels that I have lost my senses in bringing him to such a run-down shabby yard. The washing line is omitted in the first two drawings and I ask Stephen to include it in the third sketch. He looks at me in astonishment, hastily pens it and then puts his unfinished signature to the drawing which indicates 'I do not like this'. Stephen prefers the grand style, epic and imperial, or what he terms 'the great brand new'. Obviously this boatyard did not qualify for either category.

Paradoxically, it is this last impressionistic sketch which possesses a freshness, a spontaneity of vision that reveals Stephen's instinctive artistry. With a few deft strokes, he evokes the sensibility of the location and subtly captures the impossible lines of the upturned gondolas.

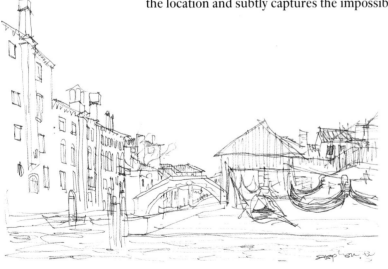

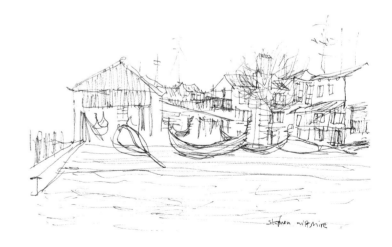

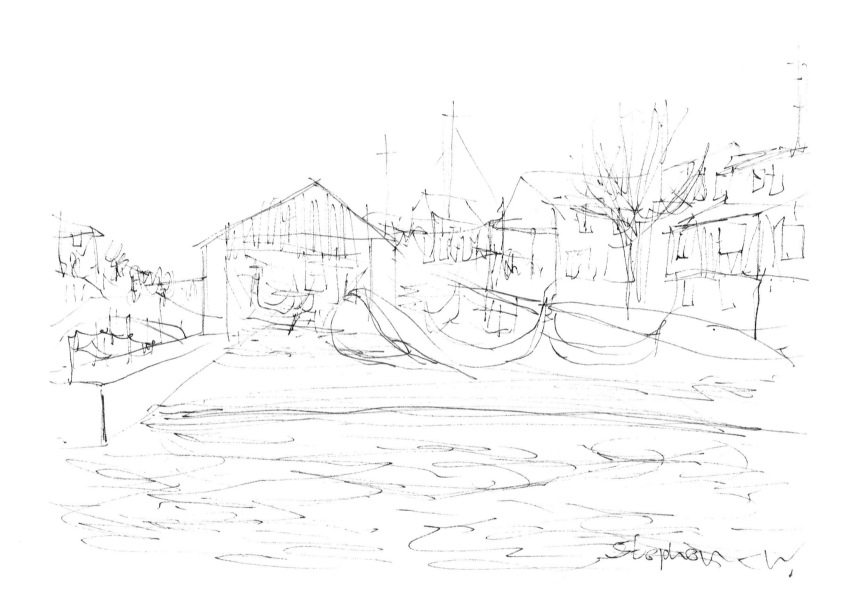

SAN TROVASO – THE SQUERO (2)

The colour drawing of the boatyard is drawn by Stephen on his return from Venice and is taken from one of his own photographs. Stephen is an indefatigable 'snapper' of buildings and cars. The results rarely match his enthusiasm but, on this occasion, his photograph is splendid and I ask him to draw it in colour for me.

It is a pencil and pen sketch which is then coloured with his crayons and the colour rubbed with his fingers to produce the required tone.

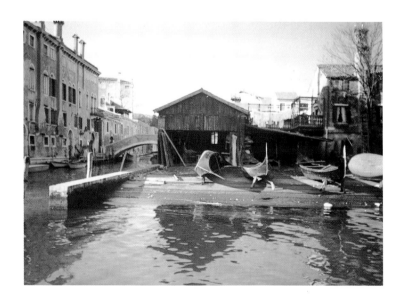

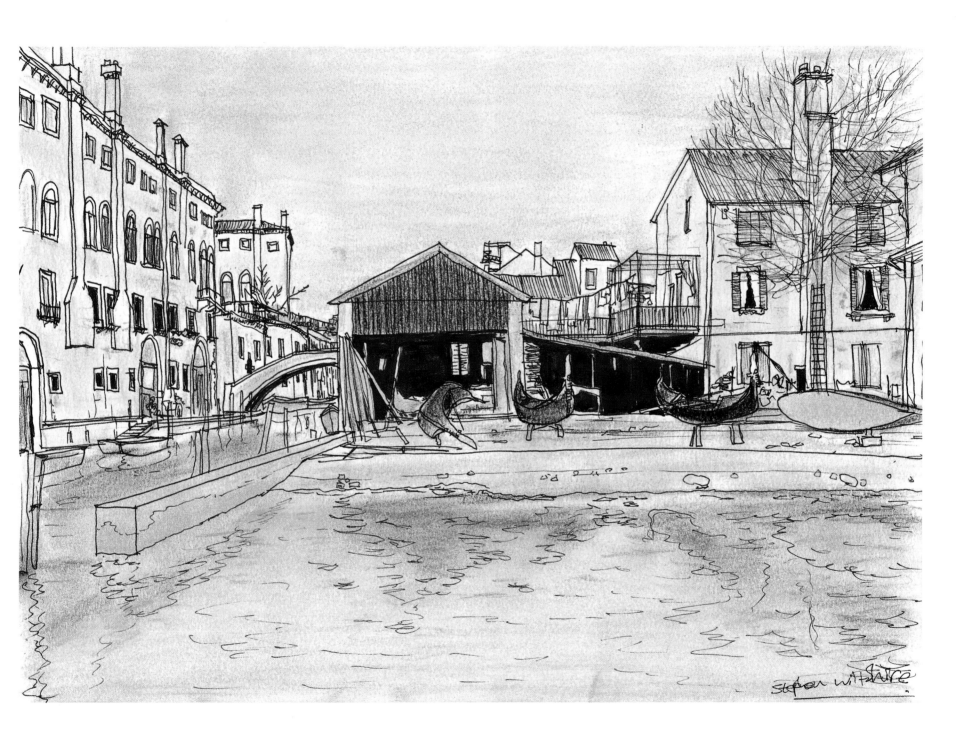

SAN GIORGIO MAGGIORE AND GONDOLAS

We buy Stephen several very large colour posters in Venice of his favourite buildings. On his return to London, Stephen draws this from one of the photographs but alters the position of the elegant tripartite light because only one branch of the lantern is visible in the photograph.

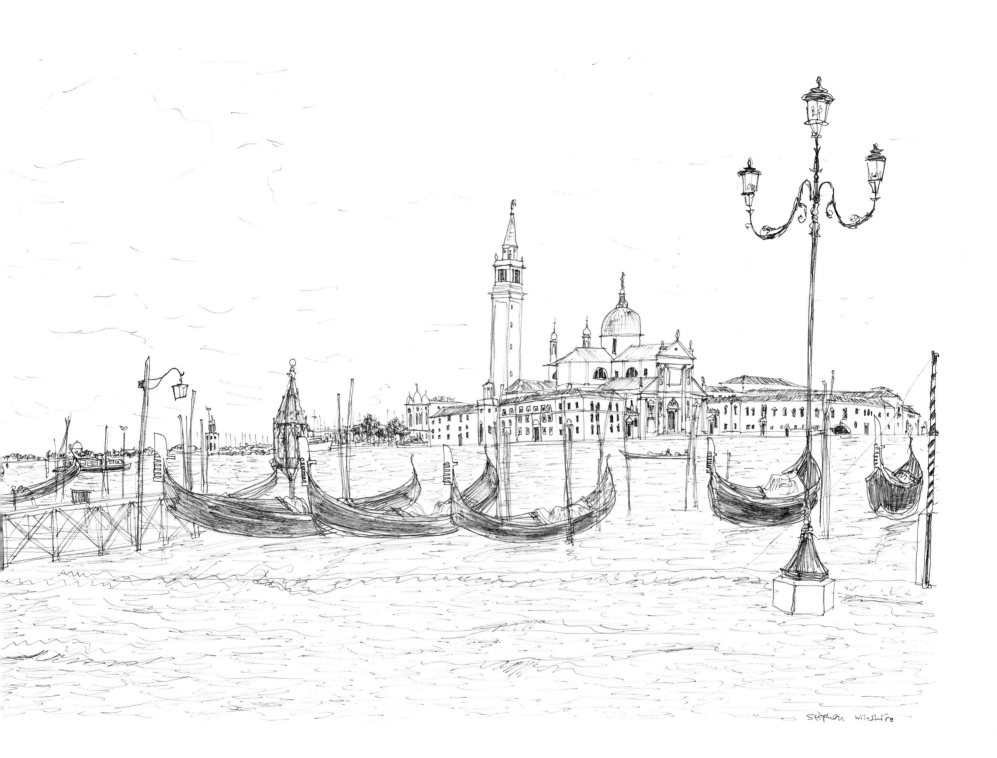

Stephen Wiltshire

AMSTERDAM

STEPHEN: 'I prefer Amsterdam to Venice because it has *cars*'

A street organ in Amsterdam.

WITH STEPHEN IN AMSTERDAM
by Lorraine Cole

When it was suggested that I might go to Amsterdam with Stephen and his family, I accepted with enthusiasm. As his ex-Head Teacher, I welcomed the chance to understand more of how Stephen had developed during his secondary education and how his extensive globe-trotting had affected him. I have great admiration for Stephen's drawings but I confess to an overriding interest in his progress as a human being.

When small, Stephen presented all the usual difficulties of the truly autistic child. He had virtually no understanding of or interest in the use of language. Other people held no apparent meaning for him except to fulfil some immediate, unspoken need; he used them as objects. He could not tolerate frustration, nor changes in routine or environment and he responded to any of these with desperate, angry roaring. He had no idea of play, no normal sense of danger and little motivation to undertake any activity except scribbling. Closed away, small and joyless, the changes in him that have taken place seemed pretty improbable at that time.

Stephen has altered a great deal. Strange people, strange places, noise, delays, physical contact, all things that once would have distressed him beyond bearing, he now takes in his stride. He responds to others with grave courtesy and his freely offered handshake is firm. Hotel life with its plastic door cards, buffet breakfasts, his own room and bathroom, situations which earlier would have been unthinkable, present no problems to him. He is a great deal more aware of the social requirement to contribute to conversations and although this often has a list-like quality – countries he has visited, buildings he has drawn or elaborate details of old American cars – it is, in his own way, spontaneous. It was good to see his thorough enjoyment of food, and his pleasure in finding that he could eat all the doughnuts he wanted for breakfast was splendidly child-like.

When he was little, nothing was amusing to Stephen. He now finds all manner of things funny and his laughter is incredibly infectious. He has gone back to caricaturing people around him, and he takes great pleasure watching his victims' reactions. Music is a big part of his life – like all people of his age, the pop charts matter and he records the latest hits and sings along with relish. He has a flair for computer graphics, loves using his camera, has been ice skating and is now in the process of moving into further training in one of the youth training schemes. All these activities widen a life that used to be appallingly restricted.

We strolled out together one evening in Amsterdam so Stephen could sketch things that were not buildings and I was intrigued by the choices he made, particularly the little statue of a man reading a newspaper and the street organ. Stephen rarely shows interest in the human figure, apart from his caricatures, but something pleased him in the statue: 'Dear little man,' he said and stroked the statue.

So much of life for people with difficulties is imposed on them – with the best will in the world it is hard to avoid – so, for me, seeing Stephen improvising movement and sound at Fred Kolman's studio was perhaps for us both the happiest time of all in Amsterdam. The sounds and the movements were under his own control, to do with as he wanted, and this chance to be in total charge of his surroundings I am sure was valuable for Stephen.

He has grown tall, his voice has deepened and he can now fit comfortably into everyday life. There is no hint of precocity or conceit about him in spite of the attention his drawing has focussed on him. He remains a gentle, gifted boy, vulnerable and somehow very touching, but he is enjoying his life fully. He has come a very long way indeed.

My son Tony lives in Amsterdam on a barge and on Sunday afternoon we join members of my family who have gathered there to meet Stephen. After one hard look at the gang-plank, Stephen walks across without apparent concern. He greets the people there with his usual grave courtesy, shakes hands and follows Tony's instructions to go down the companionway backwards as though he has done it all his life.

Once inside the boat, he takes off his coat, hangs it up, sits in an armchair, crosses his legs and appears to be completely at his ease. He manages social exchange in his usual serious way, leans forward and presents lists of places he has visited and, of course, cars that he likes particularly. He tells us, which is rather more spontaneous, that he prefers Amsterdam to Venice. The lack of roads in Venice, and subsequently the lack of old American cars, seems to have earned the Italian city a large black mark.

When Tony asks him if he would like to use the computer, Stephen jumps to his feet and races off to the wheelhouse where, using computer graphics, he designs a city. He handles the equipment with skill, using a 'mouse' which involves quite tricky thinking. When that design is finished, he wants to do another, but sadly time has run out.

He sings all the way back to the hotel and I join in which makes him laugh – perhaps my singing earns another black mark.

CENTRAL STATION

Having made the most of an excellent Dutch breakfast, selecting what he wants from the buffet with calm assurance, Stephen settles down to work on this picture. He sits at the open window of his hotel room, getting a clear view of the chosen building. He looks at the open window, thinks for a moment and then puts on his coat and scarf, sensible fellow. Stephen had noticed the station on our arrival in Amsterdam, and had drawn our attention to it, saying, 'Look – it's like St Pancras,' smiling with pleasure at this discovery.

He starts work at 10 am, first in pencil but with his pens carefully arranged within easy reach. I leave and his sister Deirdre stays to keep him company.

The drawing takes time. I replace Deirdre at 11.30 am and sit silently watching his intense concentration and enjoying the way he sings to himself 'Don't worry, be happy' while his pen races over the paper. Now and again he stops, looks intently at the building, murmurs to himself, too softly to be understood, and returns to drawing. At around 12.30 he signs his name, stands up, stretches and announces in his new, deep voice, 'It's finished.'

I ask him if he is pleased with the drawing. 'Yes, it's very nice, it's like St Pancras Station.'

He has also sketched a charmingly ornate and rather quaint street organ he has spotted outside the station.

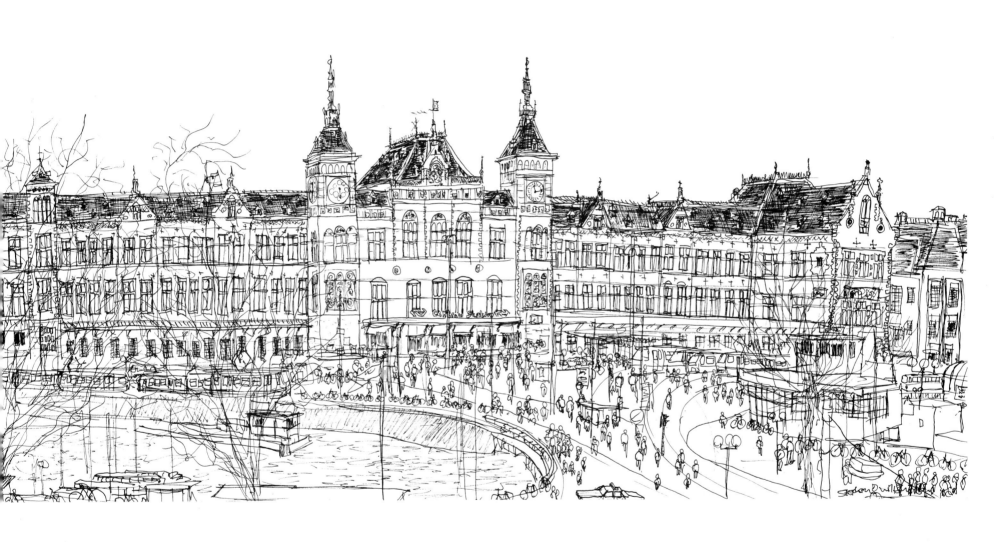

AT FRED KOLMAN'S STUDIO

Autistic people are inclined to be short of fun in their lives. They are not good at seeking it out so that it tends to pass them by. Stephen and I set off after lunch to take part in an experiment I hope will be pure fun for him. As we walk to our appointment, Stephen strides briskly, stopping only to take a great number of photographs in a casual fashion, often risking life and limb by stepping backwards into bicycle lanes. He is good in traffic now but bicycle lanes are new to him. I am glad we arrive at the studio in one piece.

The session has been arranged purely for Stephen's benefit thanks to musician Fred Kolman's generosity. The studio is electronically organised so that in a large area with a black floor and black back drop, Stephen is invited to express himself in movement as he activates an unseen bank of keyboards, high sounds at the top travelling down to low sounds. In the range of a video camera facing the area, every movement he makes produces sound and these can be varied in many different ways.

Stephen is captivated; he takes a keen interest in the equipment and grasps the concept very quickly. He moves with steadily increasing confidence and obvious pleasure, adapting mood and movements to the quality of sound and displaying a range of body and facial expression which amazes all of us watching. He prowls, drums, whirls and jumps, moving freely in the space and reaching for sounds in the air. Occasionally Fred Kolman joins him and although Stephen is warmly aware of his presence, he does not, as he so often does, mimic Fred's movements but continues his own exploration. Quite ordinary movements sometimes produce extraordinary sounds and when Stephen scratches his head, the sound it produces makes him double up with laughter.

We watch him, spellbound, enjoying his enjoyment. Often he looks at us and laughs, inviting us to share his pleasure. He is so free and happy; although originally we had thought that half an hour of movement would be enough for him, we are wrong. Stephen dances on and we haven't the heart to stop him. After an hour, however, the studio is needed and we have to go. Stephen is relaxed and happy. He watches the equipment being dismantled with interest – I have a feeling he is storing the information.

He makes his farewells and thanks Fred Kolman with his usual courtesy, and as we go back to the hotel, he looks at me and says, 'Pancakes?' It will not come as too much of a surprise that we feast on a huge pile of pancakes. Stephen finds this Dutch treat very much to his liking.

THE GNOMES' HOUSE, CENTUURBAAN

Stephen laughs when he sees this building, saying, 'It's very funny – very nice.' I ask him if he would like to draw it and he replies, 'Yes – I like the birds.' This is the first time he has picked out a special feature for me.

It is a chilly morning but Stephen is warmly dressed and seems unconcerned. When I ask him if he is warm enough, he appears irritated and replies rather crossly, 'It's all right.' Then he arranges his stools and drawing implements the way he wants them. By 10 am he is well underway, drawing fast with total confidence. He tries a few pencil strokes, rejects the notion and works in ink. Once again, he sings in snatches as he works. At one point, he laughs aloud: I ask him what is funny but he ignores me and goes back to his drawing. He is so totally engrossed that an old American car goes past and Stephen doesn't notice.

By 11.45 the drawing is finished and he is pleased with it. 'I like the birds very much.' We go to a café and have two hot chocolates each. Stephen proves better at withstanding the cold than I do.

In the afternoon, we all go to the floating flower market. His mother and sister enjoy it but Stephen is obviously very bored. He consoles himself by watching out for American cars.

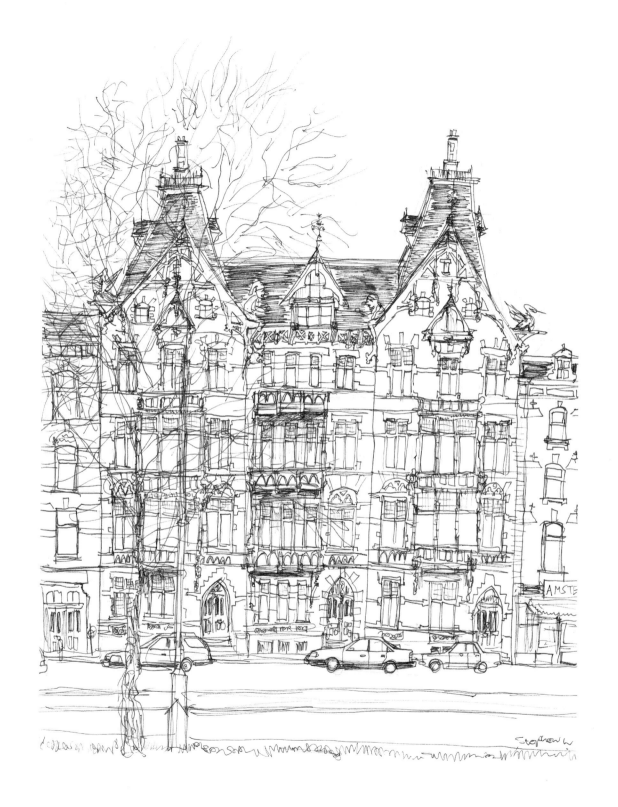

THE BARGE

Before we go to the Westerkerk, Stephen draws Tony's barge, both from memory and from a photograph. We are warm and comfortable in his room and, starting in the left-hand corner, the picture seems to flow. He works purely in ink and I have the impression that of all the drawings done in my company this is the picture he enjoys doing most. He is quiet, relaxed and his face has a gentle expression. He had doughnuts for breakfast and every now and again he says, 'Doughnuts for breakfast' and laughs. I laugh too which seems to please him.

He spends an hour on the picture and then says, 'It's finished. I like Tony's boat, I like computers.'

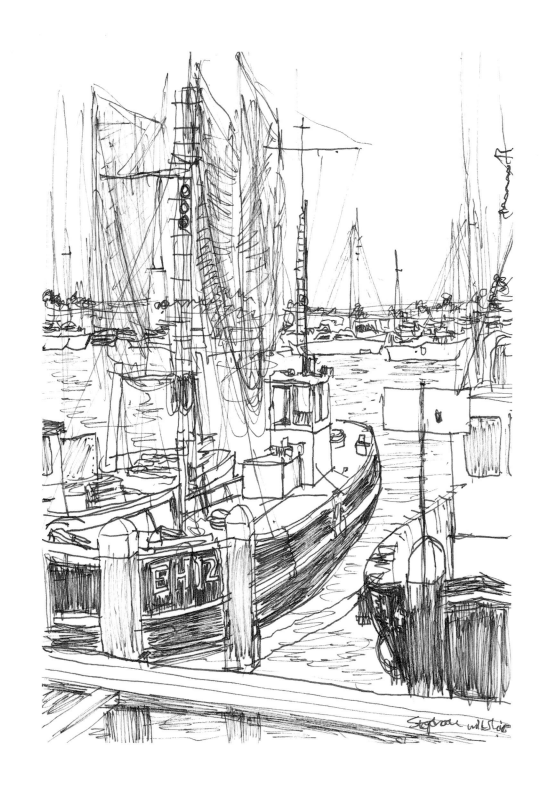

WESTERKERK

We arrive at the Westerkerk at 10 am. Stephen's mother and sister go to visit Anne Frank's house. Stephen and I cross the bridge and settle ourselves on the canal bank opposite the church. I feel this will be a difficult assignment as we cannot put much distance between Stephen and his subject. I ask him what he thinks and, with a hint of scorn, he replies, 'No, no, no, nice building, nice building.' I bow to his superior judgment.

Within ten minutes the drawing is underway, Stephen starting with the base of the tower. He is solemn and quiet for a time. Pigeons gather on the canal bank and he pauses briefly to watch them, then shrugs his shoulders and returns to the drawing. Passers-by frequently do double-takes when they pause to look at his drawing. Stephen takes no notice of them and out of an innate respect for the privacy of others, no one intrudes on the strange little person drawing so beautifully and with such intensity. Amsterdam is a good place for artists. He is quiet, not singing, not murmuring.

He finishes the drawing at midday just as it starts to rain. He stands up, looks at me expectantly and says, 'American cars?' So off we go on a car hunt.

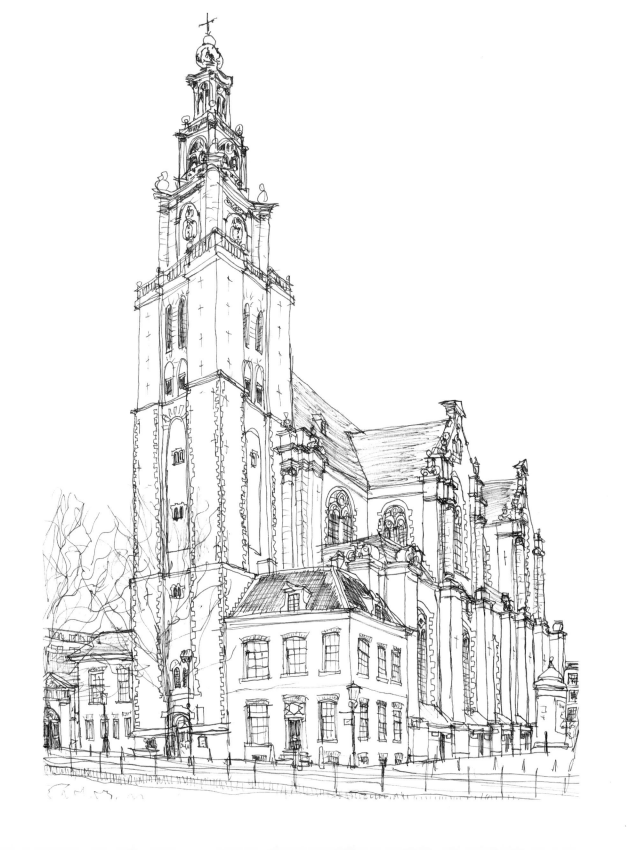

ST NICOLAAS

Stephen is staying with his family in the Victoria Hotel which overlooks both this church and the station. Andrew and I walk over from our hotel, the Ambassade, to join him. The three of us will spend the day drawing in the city, but first I take him to the coffee bar in the Victoria Hotel and ask him to pen this sketch of the nineteenth-century church while he drinks. His keen eye picks out the overhead tramlines and the parked bicycles on the bridge in the foreground.

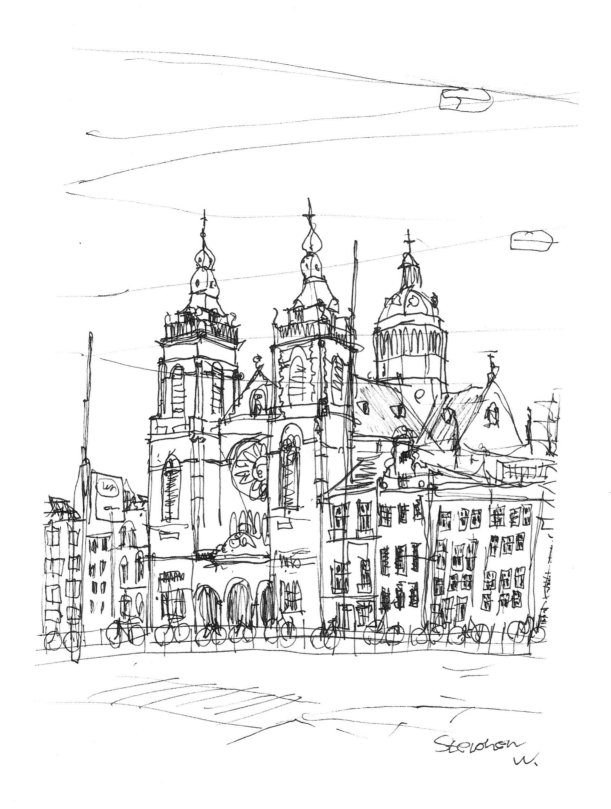

Stephen
W.

THE AMSTEL RIVER

This large drawing on A2 paper is executed under the most difficult circumstances. It is very cold and the rain splutters on to the pad within five minutes of our arrival on the riverside. As Stephen is working in pen, which will smudge in the rain, Andrew and I improvise with an umbrella and my large woollen wrap which I normally use to keep Stephen warm. The wrap is placed over the entire A2 pad and Stephen works on each detail, section by section, which I uncover when he is ready.

This is the oldest wooden drawbridge over the Amstel and we watch it being raised as a cargo-ship approaches.

Stephen begins with the moored houseboats in the foreground, moving on to the bridge and then the houses on the other side of the canal. A pair of great crested grebes perform their spring mating display in front of us but Stephen ignores them.

The river has an energy and vitality in marked contrast to the artificial canals which is why we chose this view. Stephen's drawing possesses the freshness and dynamism of river life which is quite unlike the serenity of Herengracht.

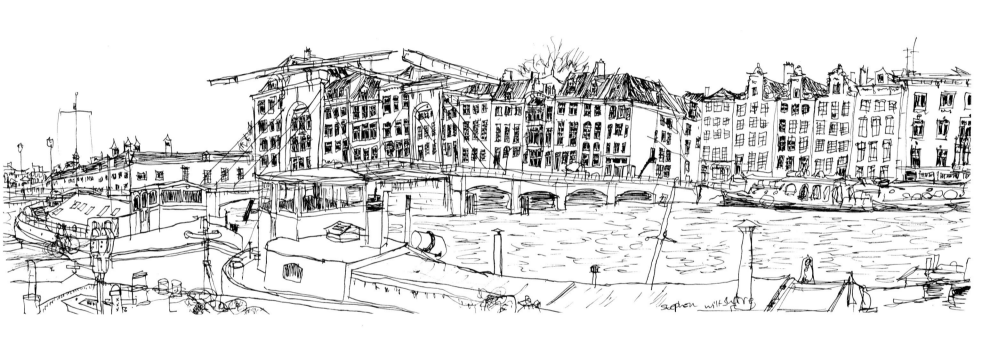

VIEW FROM THE AMSTEL HOTEL

Andrew, Stephen and I seek sanctuary in the Amstel Hotel after Stephen has drawn the Amstel bridge because it is raining and cold. Hot chocolate and a pile of pancakes restore the circulation.

This is the view from the bar of the hotel overlooking the river, with the Dutch Bank towering in the background. Stephen is not using his usual pen because foolishly I have left the box in the hotel. I find a substitute but the nib is really too thick for his taste.

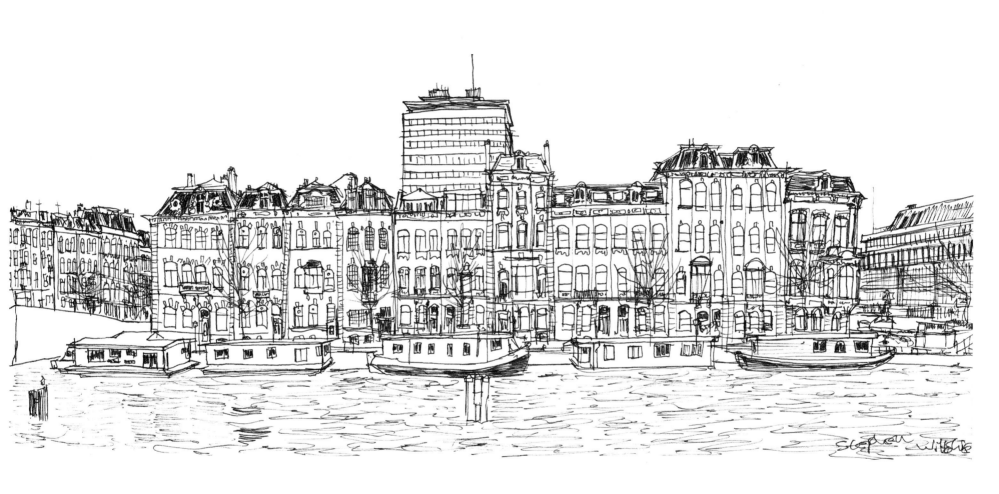

HERENGRACHT

The houses on this elegant canal testify to Amsterdam's burgher wealth in the Golden Age. Understated, sober, quietly confident, they reveal much of the northern merchant spirit.

I choose a particular section of this canal for Stephen to draw because it contains a florid, ostentatious, mannerist façade which is quite splendid and in sharp contrast to its restrained neighbours. Stephen sits on the opposite side of the canal to draw. It is extremely cold and he is wearing thick woollen gloves. This is his second drawing in Amsterdam and he is introduced to the characteristic features of these tall houses with their stepped, bell or neck gables – features which he reproduces later in the day in a quick memory sketch in the hotel. The atmosphere of the canal is caught well and Stephen is pleased with his finished work.

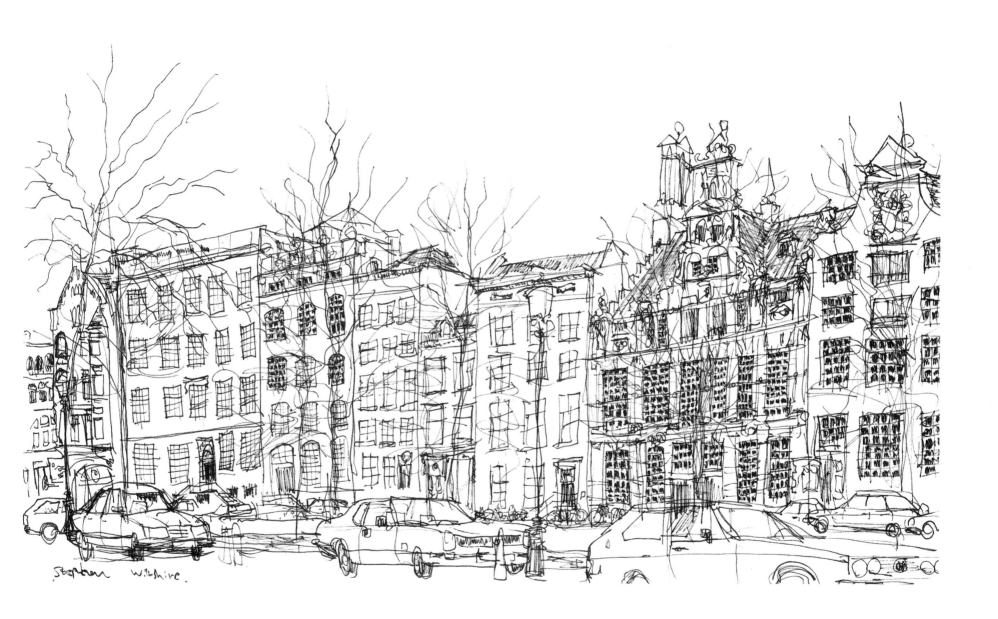

Stephen Wiltshire.

VIEW DOWN BLOEMGRACHT

Stephen is seated on a small bridge opposite Anne Frank's house, No. 263 Prinsengracht, looking down Bloemgracht, a canal street at right angles to Prinsengracht. Although more modest than the houses on the main canals, Bloemgracht has a quiet charm. It is a typical view of Amsterdam with its tall, gabled houses, houseboats, tree-lined canals, parked cars and bicycles.

This drawing perfectly captures the serenity of a Sunday afternoon in Bloemgracht.

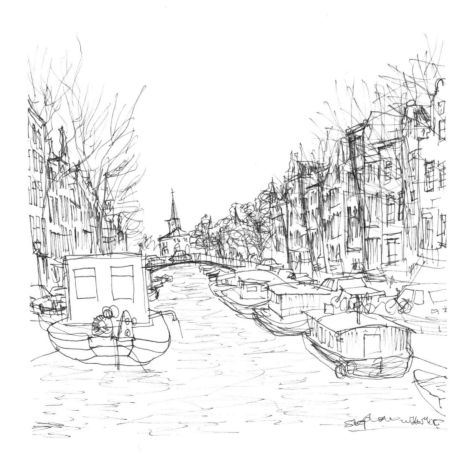

A CORNER OF BLOEMGRACHT

The bicycles against the iron railings on the bridge in this sketch provide Stephen's signature tune to Amsterdam. The speed and the ease with which he pens the curve of the railing and the leaning bicycles is delightful to watch.

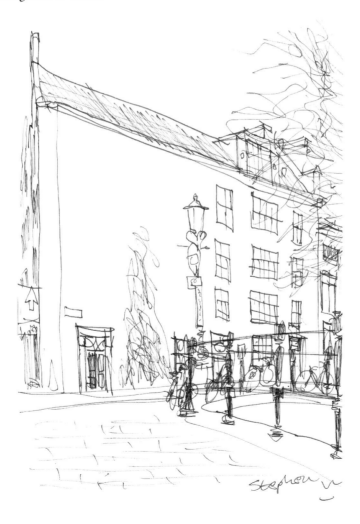

KONINKLIJK PALEIS

We are having lunch in a corner café which overlooks the Royal Palace. Stephen has ordered his steak and chips and this drawing is penned while we talk. Originally built as the Town Hall in the seventeenth century, it is now a royal palace.

From where he is sitting, Stephen can see exactly what he shows in the drawing – the classical façade flanked by buildings on either side. Beatles songs are being played on the juke box and Stephen joins in, mouthing the words as he draws.

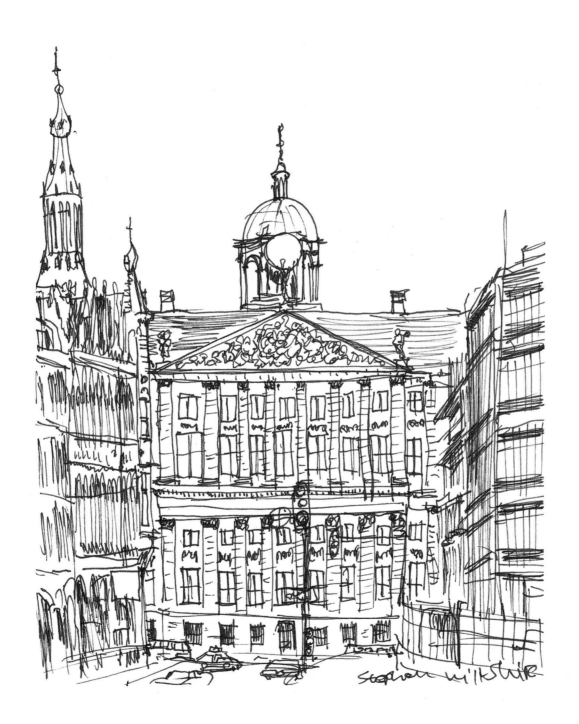

THE BEGIJNHOF

These charming old houses are built around an enclosed area which features the English Church from where Stephen executes this drawing in pen. The quaint irregularity of the buildings encircling the grass and trees is beautifully evoked and Stephen's ability to suggest the gnarled tree trunk in the foreground is an interesting new development in his visual awareness.

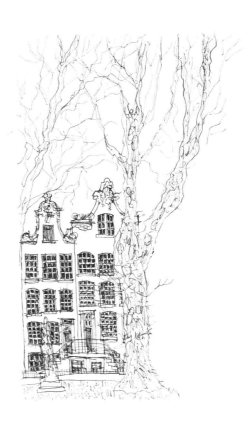

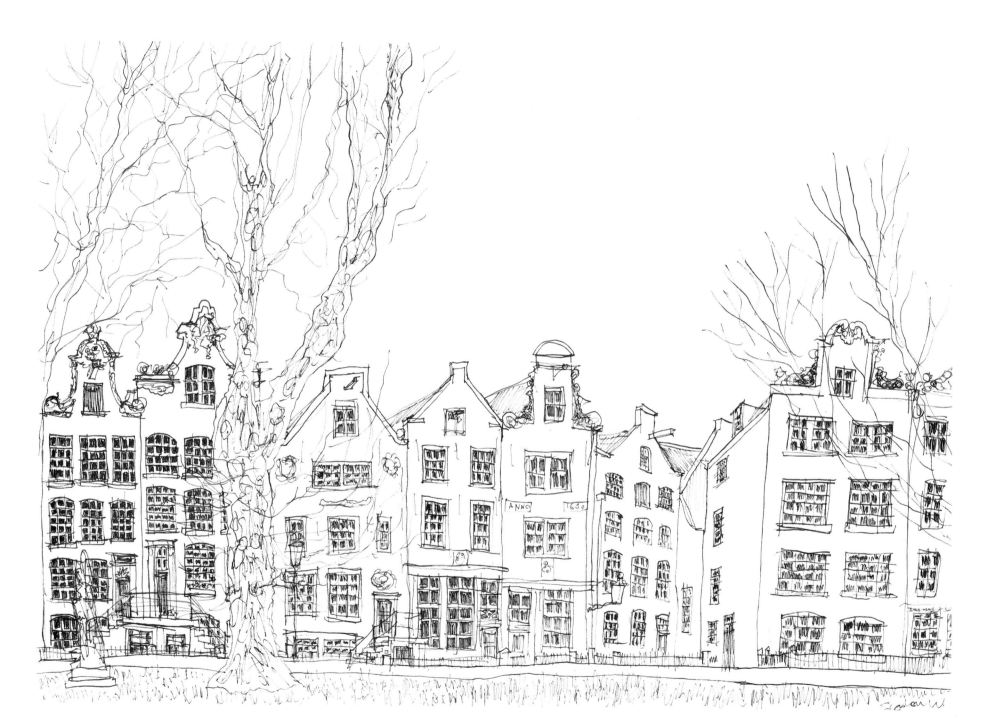

MOSCOW

Margaret Hewson: 'Stephen, what is your impression of Moscow?'

Stephen: 'Dollars, dollars, give me dollars!'

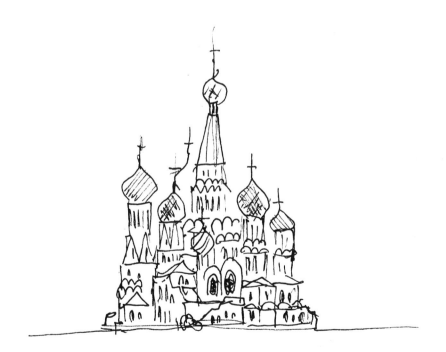

PORTRAIT OF DR OLIVER SACKS

Stephen and I discuss the forthcoming arrival of Dr Oliver Sacks in London because 'the genius man', as Stephen calls the doctor, intends joining us on our Russian excursion. Stephen has not seen Oliver for a year and I wonder if he will be able to recall the doctor's features. I give Stephen a sheet of paper and a pen and ask for a lightning portrait from memory.

While Oliver's beard has acquired a magnitude which rivals that of Santa Claus, the glasses have not been forgotten and the shape of the face is well caught. Oliver's baldness is also suggested and the central wisp of hair is remembered as is the overall build of this large gentleman, evoked by the two shoulder lines. It is interesting to note that Stephen did not choose to caricature the doctor but produced a brilliant pen sketch.

It is unusual for Stephen to draw portraits because his interest in people is invariably superseded by cars or buildings. The portraits are normally caricatures unless he feels a particular affection or respect for his subject.

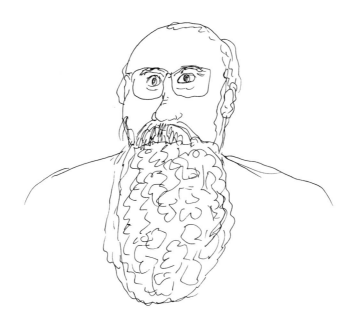

SPAASKY TOWER

This is Stephen's first drawing in Moscow. He is seated on his travelling stool in front of St Basil's to draw this tower which forms part of the Kremlin walls. His drawing pad is placed on the second travelling stool and he decides to start in pencil. Oliver Sacks sits on a wall in front of Stephen, taking notes. It is sunny but chilly, and Stephen jumps every time the police blow their whistles at foreign tourists who have strayed from the designated pedestrian crossings on the square: everyone must walk in formation, preferably in groups.

As a child, Stephen manifested a nervous head-twitch which had disappeared within the last year. Suddenly, it reasserts itself as he is drawing. He is tense and silent and appears to be unnerved by the strange atmosphere. Autistic children undoubtedly possess a sixth sense which transcends language, and Stephen is remarkably accurate in gauging tension and mood. His ability to detect unease verges on the paranormal.

The drawing is completed in pen after his ten-minute pencil sketch has outlined the tower. One hour later, the drawing is finished.

We walk across Red Square to look at the History Museum. Stephen slips his arm into mine and I ask him to study the building carefully because I want him to reproduce it from memory on our return to the hotel.

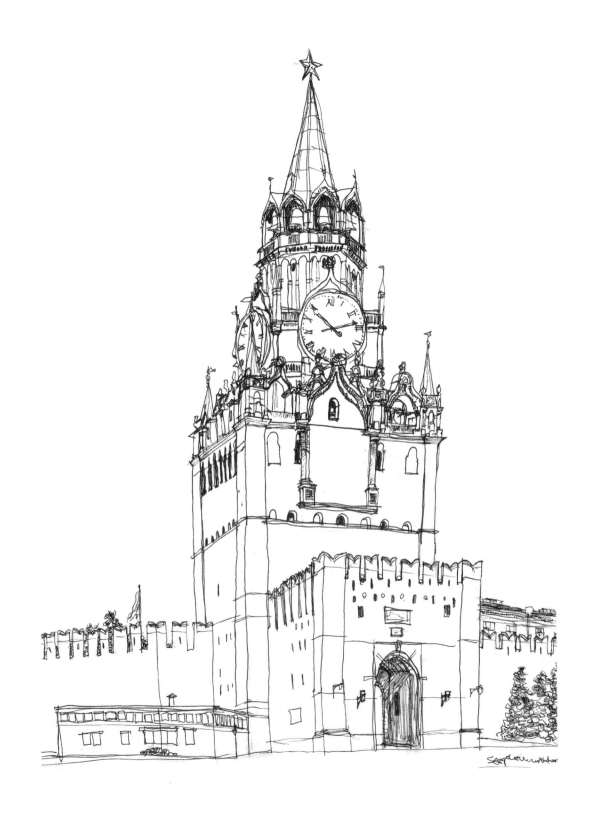

AERIAL VIEW OF THE KREMLIN

Stephen translates the illustrated photograph in pen. Both drawing and photograph are shown to highlight Stephen's dazzling visual facility to reproduce the perspective. APN Picture Library supplied us with photographs of Moscow and Leningrad prior to our trip, and this aerial view had been chosen for the combination of intricate detail and complex perspective.

Stephen responds enthusiastically to it, taking four and a half hours to complete a brilliant picture. The detail on the Kremlin Palace is picked out from another photograph which Stephen had been shown the previous week.

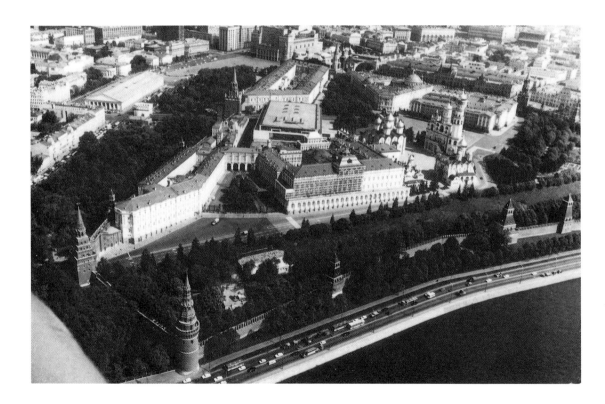

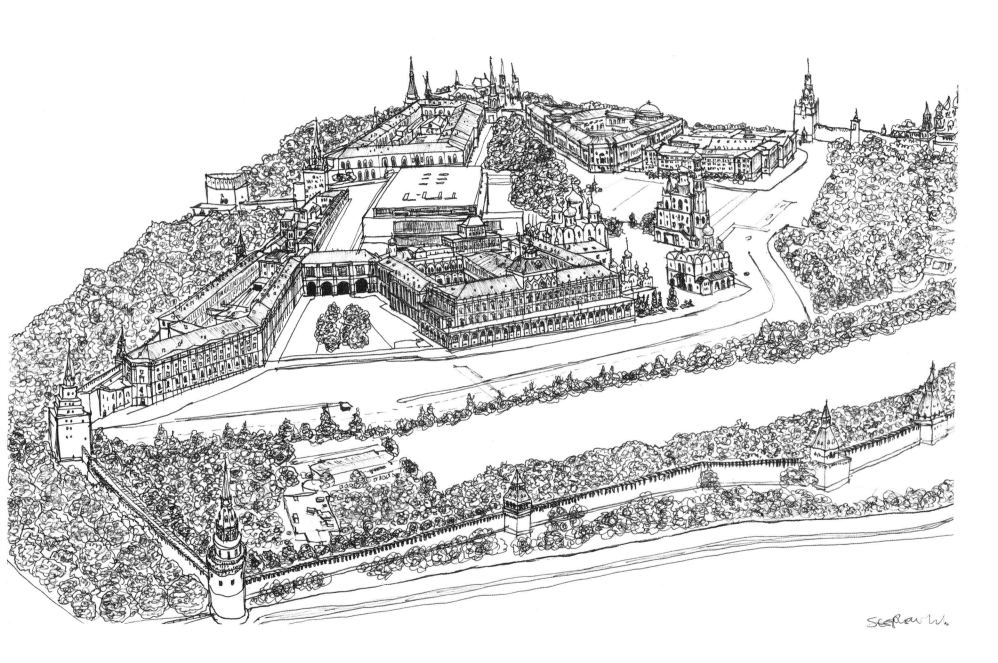

THE KREMLIN PALACE

This is a companion piece to the aerial view of Moscow on the previous page, and it is from that photograph that Stephen picks out the vocabulary of the Kremlin Palace for the aerial view drawing.

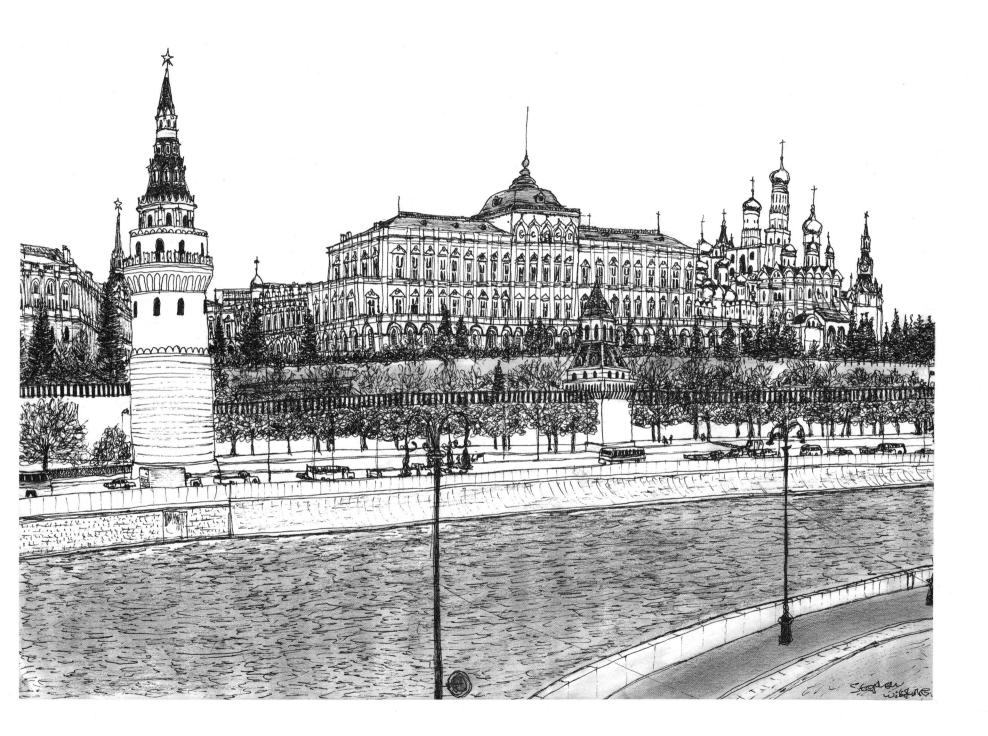

'THIS IS *NOT* THE HISTORY MUSEUM'

Stephen is drinking a coke as Oliver, my colleague Jaqi and I have some warming coffee after our morning in Red Square. I ask Stephen to draw the History Museum from memory and he produces this drawing. Clearly it is not the building he and I have been studying, but what is it? I ask Stephen and he says in an authoritative tone, 'This is *not* the History Museum!'

'Is it imaginative?'

'Imaginative,' replies Stephen.

My leading question is not helpful because the answer could be an example of Stephen's echolalia. I prefer his original negative reply. He then draws his favourite building, St Basil's (shown on this section's introductory page), immediately afterwards and the magical nature of his art is suddenly there in a two-minute sketch.

Stephen's inability to reproduce the History Museum from memory suggests that he is still ill at ease. We go to our bedrooms to leave sketching pads and stools, and Stephen suddenly bursts into my room to announce: 'Margaret, there are no Cadillacs in Moscow, no classic cars, there are no Chevrolets, no Buicks, no Lincoln Continentals – no, not in Moscow.' This monologue is delivered with real emotion and much hand movement. It is entirely heartfelt, not a response to a question. Stephen is economical with language except on the rare occasions when he wishes to communicate a vital piece of information.

Stephen W.

NOVODEVICHIY CONVENT

Oliver, Jaqi, Stephen and I take a taxi to this convent. The taxi drivers stand in a predatory group outside the hotel awaiting their foreign victims who represent dollar bills. After a five-minute interchange in Russian between Jaqi and the taxi-drivers, which Stephen appears to ignore, one of the drivers agrees to take us to the convent, wait for two hours and then return us to the hotel.

It is a beautiful, sunny afternoon and this magnificent convent set in a rambling garden is in sharp contrast to the military formality of Red Square. It is delightful to escape the all-pervasive petrol fumes of the city and enter a restful, non-aggressive environment. Russian painters work at their easels, lovers stroll hand in hand and old men sit smoking on the garden benches. Stephen and Oliver sit side by side, both drawing. Stephen's nervous tic has disappeared and he is completely at ease. He pencils the building on an A2 pad and then colours the domes, smudging the crayon in his usual fashion. When Oliver shows Stephen his quick sketch of the same view, Stephen says, 'Well . . .' and smiles broadly. These sententiously brief pronouncements on the part of Stephen are most engaging.

I name all the trees for Stephen: limes, sycamores, oaks, lilacs in blossom, and point out the wild flowers which are growing amongst the long grass. Birdsong is the only sound, and there are no police whistles.

When, after 1¼ hours, the drawing is finished, Stephen and I walk around the convent and Stephen draws a two-minute pen sketch of the front elevation of the cathedral as we talk. This little sketch is really the result of having absorbed the architectural language and proportions of the building earlier in the afternoon and he is now able to produce the essence and character of the sixteenth-century cathedral which combines features of both Italian architecture and ancient Russian design.

Peter the Great dumped his first wife here after he had grown tired of her. The cemetery within the high crenellated brick walls which surround the convent precincts is the burial ground for many eminent Russian writers and musicians including Gogol, Chekhov and Prokofiev.

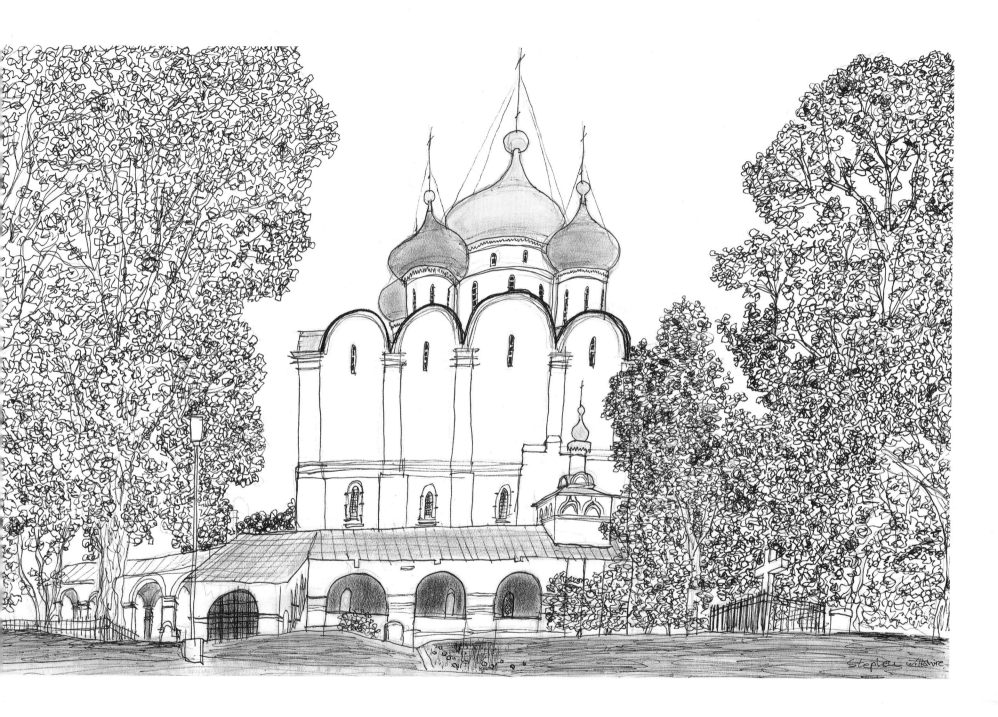

GUM

Springtime in Moscow is exhilarating. It is another beautiful day and Intourist provides us with a bus which is at our disposal throughout our trip. Jaqi, Stephen and I are driven to GUM, the largest department store in the Soviet Union, which stands on the corner of Red Square. On the way Stephen scribbles a little drawing of the Moscow street we are driving along.

Built in the 1890s, the stern exterior of GUM conceals a truly splendid interior. We climb the stairs to a bridge on the first floor of the store, fighting our way through the crowds of shoppers.

When Stephen is seated on his travelling stool, we marvel at the revolutionary metal skeleton which supports the glass-arcaded roof. On either side of us there are stuccoed arcades. This site is chosen because the perspective is challenging and I ask Stephen to draw the view from where he is seated.

'Is it too difficult?'

'No, it's fine, just fine,' says Stephen.

He begins to draw in pen with no prior pencil sketch. The central roof-line is drawn first and then the lines radiating outwards from the central ridge. It is astonishing to watch and passers-by gasp in amazement. A Mongolian horde swarm around us; they are queuing from the ground floor, four abreast, up the stairs to the entrance of a shop right beside us which appears to have four pink shirts for sale. Stephen wants to know what is happening and so Jaqi goes off to investigate. A consignment of white cotton shirts, considerably cheaper than the four pink ones on display, has just arrived. They clearly represent a much sought-after bargain, judging by the pulsating crowds. Suddenly, we appear to be in the middle of bedlam as a female queue-barger is accosted by the hordes and a fight breaks out. We grab Stephen and make the fastest exit possible before we are unwittingly part of the riot.

Stephen's drawing has not been completed. The right-hand shop arcades have not yet been drawn but the shop signs, with the complicated cyrillic script, are already in place. The drawing is completed the following evening in the hotel.

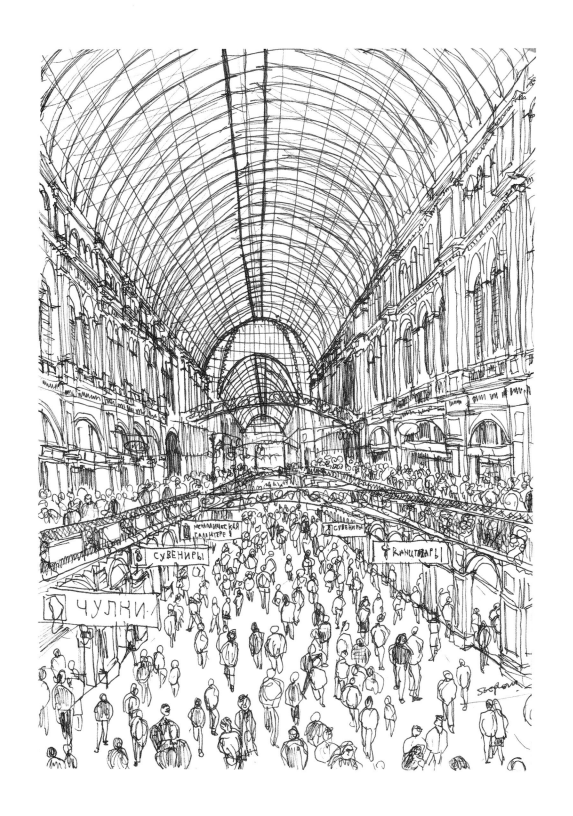

THE HISTORY MUSEUM

This building was designed by an English architect, Sherwood, in the late nineteenth century. It stands at the north end of Red Square, directly opposite the multi-coloured anarchic rhythms of St Basil's, and is an eclectic confection of styles in red brick.

Stephen pens the central doorway in ink and roars with laughter every time I mention the *Not The History Museum* drawing. We spend only twenty minutes in front of this façade because we are due at the British Embassy at 3 pm. Oliver, Jaqi, Stephen and I are then driven across the Moskva river to the Embassy in our bus.

The History Museum is completed the following day when we return to Red Square and seat Stephen in exactly the same position as the previous day. Jaqi sits on the ground beside Stephen but a guard immediately advances, waving his baton, and shouts at her to get up. Red Square is an acquired taste.

Our little party is taken for lunch to McDonald's who have kindly arranged for Stephen to be given the diet he most likes. The queues to the restaurant exceed those to Lenin's tomb and our Western-conditioned eyes are amazed. The hospitality of the restaurant manager is delightful and we are most grateful for this preferential treatment as we slip through the side door. Stephen is immediately at home in this environment and we are ushered to a table with our cokes, hamburgers and ice creams which Stephen devours with much enjoyment.

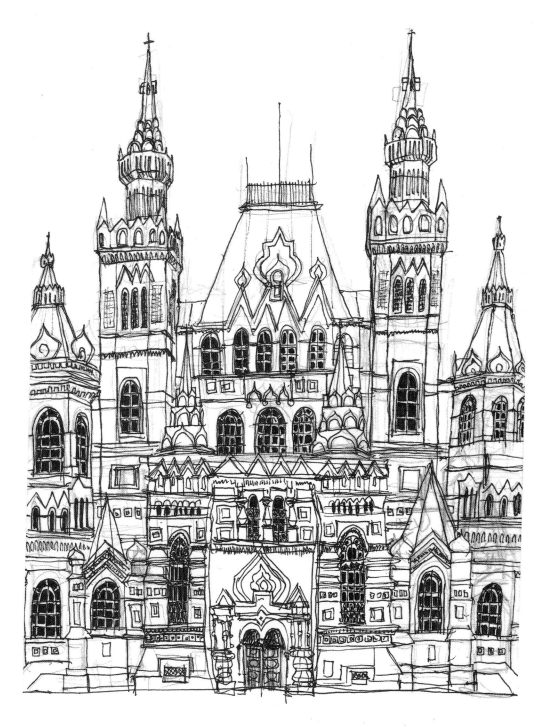

Stephen Wiltshire

TEA AT THE BRITISH EMBASSY

When filming with Stephen in London, Sir Hugh Casson suggested that Stephen should draw the neo-Gothic bathroom at the British Embassy in Moscow. On our arrival, I telephone the Embassy to arrange a visit. The Embassy staff are wonderful: cooperative, witty, informative and supremely hospitable.

We arrive on time at 3 pm and Stephen is introduced to Carmel Power, Lady Braithwaite's social secretary who has been astonishingly helpful. Stephen says nothing: this is most unusual because he is normally extremely polite. I take him upstairs to show him the splendid bathroom which I want him to draw. It must be the best lavatory-seat view anywhere in the world. Stephen looks around the bathroom in a disengaged manner. He refuses to draw it, saying succinctly, 'Definitely not.'

I surrender and we walk to the balcony on the first floor which commands a superlative view of the Kremlin. It is very hot, the domes of the Kremlin cathedrals glint in the sunlight and Stephen's nervous tic reasserts itself.

Lady Braithwaite.

Stephen Wiltshire

Stephen is still disinclined to draw, saying he is tired, but I explain to him that the drawing from the balcony will have to be drawn this afternoon because we can't pop back next week. He smiles and reluctantly picks up his pencil. I set him up with a chair from the sitting-room and place his pad on the balcony surround.

Tea is served and Oliver, like Badger in the *Wind in the Willows*, ambles off into the comfort of an English armchair for an afternoon snooze. I sit beside Stephen and suggest that we sing his favourite songs but he refuses to respond and simply says, every ten minutes, 'I'll just stop now'. It is wrong to force Stephen to draw when clearly he would rather not but this view is not an everyday event. Normally, when he doesn't wish to draw a building, he simply sketches a rough outline, signs his name and hands it back to me saying, 'Finished'. Today, however, this does not happen. He draws the cathedrals in detail and then moves to the tower on the far left-hand side.

Oliver emerges from his lair and he and Jaqi take photographs of Stephen drawing. We are joined by the BBC producer/director Tony Edwards as Stephen puts the finishing touches to his work. The traffic on the road across the Moskva river is not included which is most unusual. 'No cars, no buses are going into this drawing,' Stephen announces. I am relieved that the view has been drawn and leave Stephen to complete the foliage.

When Stephen has finished, we are joined by Lady Braithwaite, the Ambassador's wife, who gives us a conducted tour of the Embassy rooms she thinks will appeal to Stephen. He is still uncommunicative but as we return to the sitting-room where we have left the drawing materials, Stephen suddenly dives into the room opposite and asks, 'What's this room?' Lady Braithwaite explains that it is her private family sitting-room and I notice that Stephen is scanning the tables and bookcases. 'Have you got any car magazines?' asks Stephen.

The intuition and ingenuity of Lady Braithwaite is wonderful. She disappears and returns with a toy Volga which had once been given to her husband but who, presumably, has now outgrown it. She gives it to Stephen as a present. He is transformed. Speech is immediately restored and he embarks on one of his list-like speeches: 'I like Moscow. I like Russian cars [untrue] and I like Cadillacs, Chevrolets, Mercedes, Escort RS Turbos . . .' The litany is relentless and he is supremely happy once again. We depart with a smiling artist clutching his toy car.

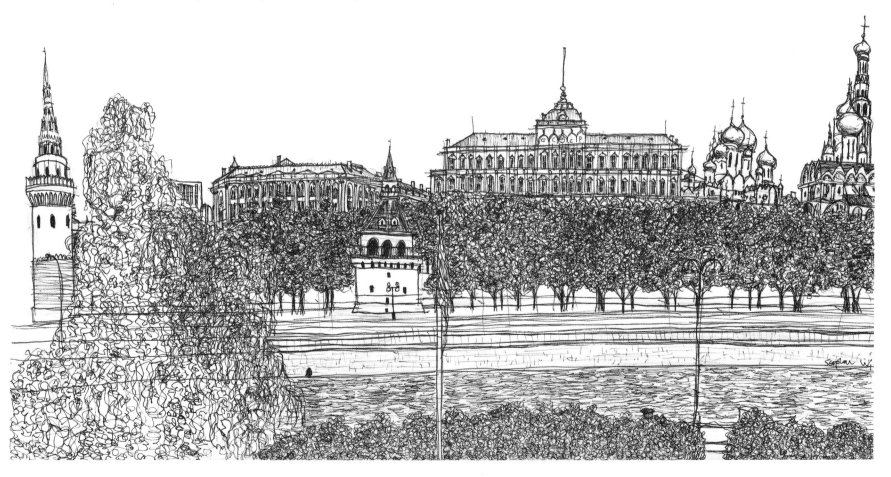

ST BASIL'S CATHEDRAL

This drawing is executed from a poster provided by Thomson Holidays prior to our Russian trip. It seemed appropriate to introduce Stephen to what epitomises Russian architecture to Westerners: clusters of multi-coloured onion domes which Stephen found most entertaining. Ivan the Terrible, who commissioned the building in 1552, is alleged to have demanded that the architect's eyes be gouged out to ensure the unique nature of this edifice. He may have unwittingly rendered an aesthetic service to posterity – depending on one's tastes.

The drawing was first executed in pencil, coloured with crayons and then smudged – a technique which Stephen learned by watching Tony Hart on television some years previously. The architectural detail is finally emphasised by outlining in pen.

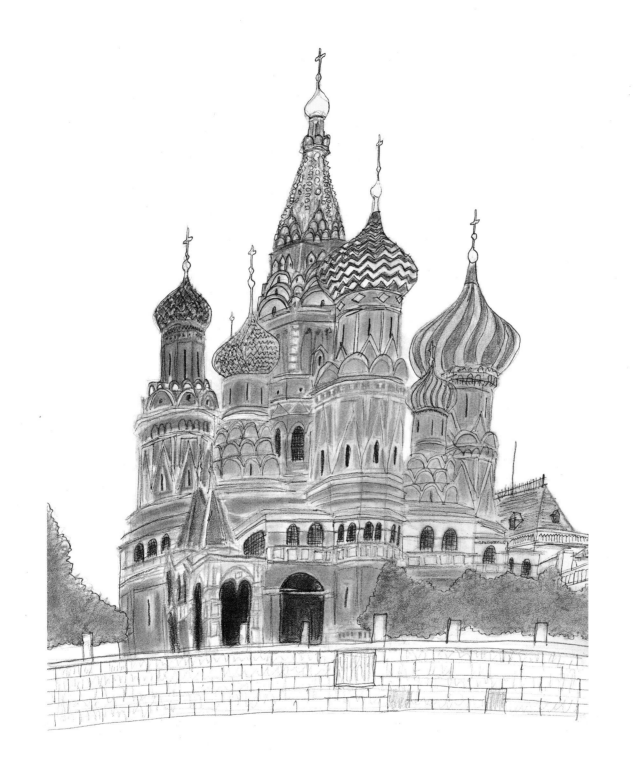

ST BASIL'S CATHEDRAL (2)

This is the view of St Basil's as one approaches Red Square from the Moskva river. It is Stephen's favourite building in Moscow and Stephen decides to abandon his pencil and draws directly in pen. He is seated beside our bus in the car park which commands this excellent view. An occasional cursory glance is directed towards the cathedral but Stephen barely raises his head to look at the building. I am sure that if he had turned his back to St Basil's, the same drawing would have been produced.

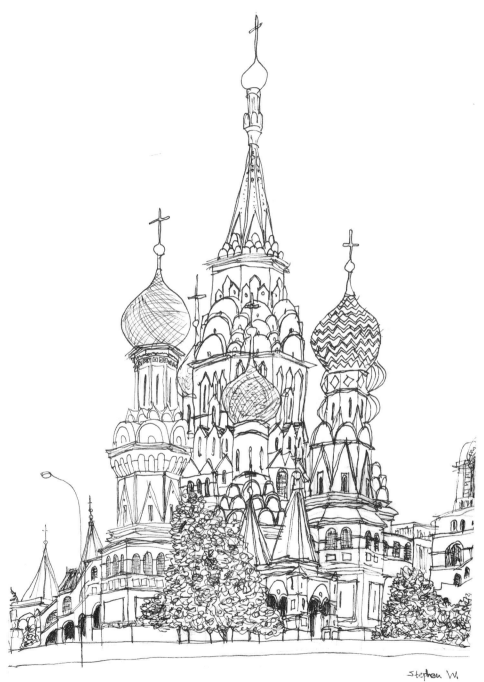

Stephen W

THE BRITISH EMBASSY (2)

This pencil drawing of the British Embassy is filmed by Tony Edwards and his film crew. In the rain, Stephen studies the front of this neo-classical façade for four minutes. He is then asked to reproduce it from memory. The drawing is accurate in its architectural detail except for the front steps which do not approach the building from the sides as illustrated but from the front. A further memory drawing is executed in pencil and pen, but this time two Zils are included. A Zil had swept into the Embassy as Stephen and I were leaving after the four-minute study. I point to the two cars in the drawing and the following conversation takes place:

STEPHEN: 'These are Zils.'

ME: 'How do you know?'

STEPHEN: 'I've seen them on the tele. Mrs Thatcher at 10 Downing Street with Russians. Buckingham Palace, too.'

ME: 'But how do you know the name of this car?'

STEPHEN: 'I've seen them in a car magazine.'

The British Embassy is built on an island with the Moskva river in front and a canal behind. It is the nearest we shall come to Moscow as a floating city!

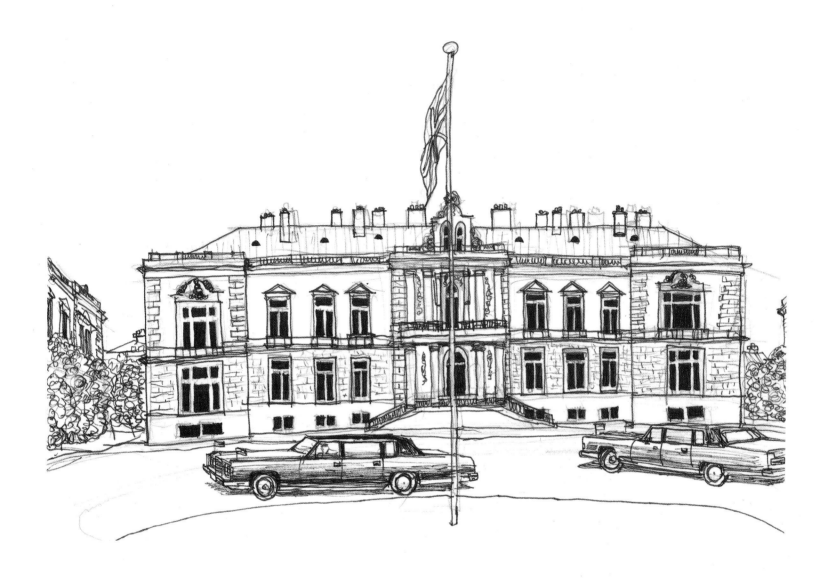

We are driven to Red Square where more filming takes place. Stephen and I are asked to watch the changing of the guards at Lenin's tomb and we cross the square chatting to each other. I suggest to Stephen that the square would be much enhanced with a bit of grass and a few sheep grazing, perhaps the odd goat, too.

THE DON MONASTERY: The New Cathedral

On our last day in Moscow, we ask our driver to take us to the Don monastery in the morning, immediately after breakfast. Jaqi, Stephen and I are joined by our Intourist interpreter who decides to spend the day with us.

This fortified monastery, dating from 1591, was built to commemorate Boris Godunov's victory over the Crimean Tatars. It is without doubt the most enchanting, fascinating ensemble in the whole of Moscow. It lacks the obvious charm of Novodevichiy but it is much richer and far more subtle in character and atmosphere. Stephen is very relaxed today. There is no head twitching and he is keenly interested in his surroundings. It is a beautifully hot morning and, on arrival, we set his travelling stools in position and he draws the massive brick New Cathedral which is veiled in scaffolding. Vast restoration work is taking place all over Moscow. The charm of buildings in decay clearly does not appeal to the Russian mentality. Ruins must be restored to their pristine splendour. Fountains Abbey would probably be fully reconstructed were the Russians in charge.

Stephen likes the scaffolding on the building and sketches first in pencil then in pen. He is supremely happy, and it is delightful to see such controlled energy at work. The monastery grounds are quite overgrown with wild lupins, forget-me-nots, dandelions and lilac, and there is an abandoned orchard covered in white apple blossom.

This idyllic setting has a miraculously calming effect on Stephen and he tells me, as I sit beside him, that 'This drawing will be great'. Indeed it is, and is completed after forty-five minutes.

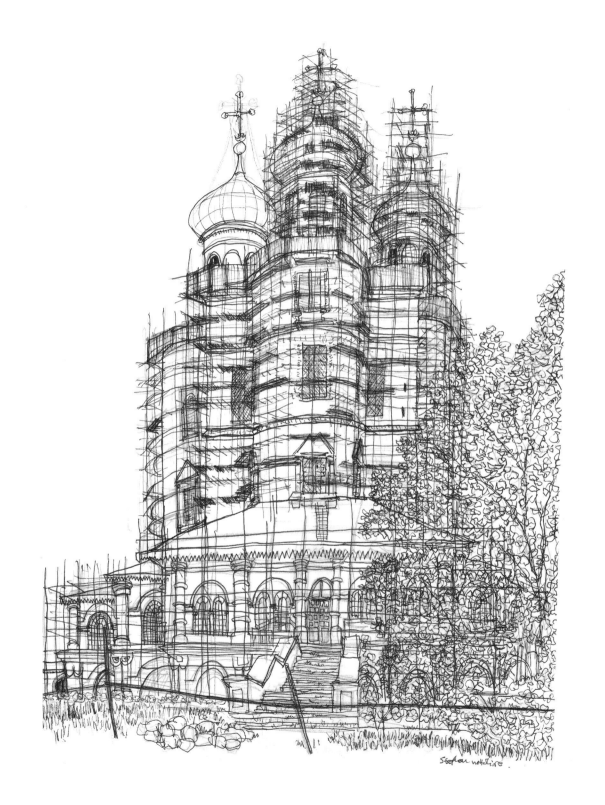

Stephen Wiltshire

DON MONASTERY:
The Church of St John Chrysostom

We stroll through the tree-lined glades when Stephen has finished the New Cathedral and come across this nineteenth-century neo-Byzantine family chapel. I ask Stephen to draw it from the only angle which allows the best view – trees obscure the building from most sides – and set up his travelling stools. He is in direct sunlight and so I give him my sunglasses and he becomes Ray Charles. Smiling and laughing, he pencils this sketch first and then pens it.

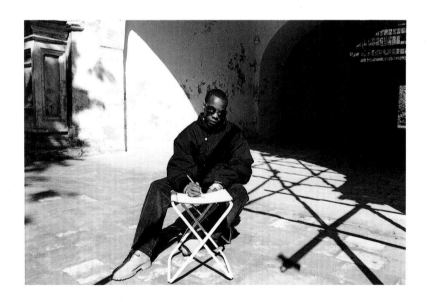

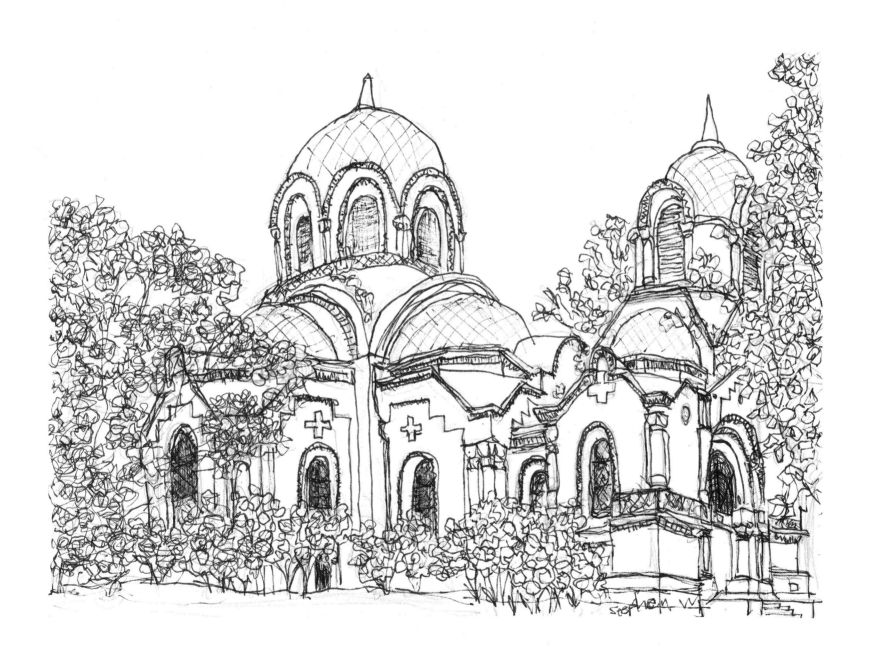

DON MONASTERY:
The Chapel of the Tereshchenkos

Stephen, Jaqi and I walk with our Russian interpreter through the grounds of the Don monastery, back to our bus which is waiting for us. On the way, we pass this charming neo-Russian chapel built in 1899 and I ask Stephen to draw a quick sketch of it for me before we leave this enchanted monastery. I place his stool on the small path in front of the chapel and he sketches the building in pencil. While he is drawing, I push open the door of the chapel and step inside – to be met by two astonished Russian boys who are restoring the chapel. One of them is a painter and his oil paintings are propped up on an easel inside the chapel. I introduce myself in English and resort to sign language because I want them to meet Stephen. Our interpreter is summoned to act as go-between and the boys join our little party to watch Stephen draw.

'How do you do, I'm Stephen,' announces our artist. He continues to draw but is fascinated by the dialogue in English and Russian and the laughter. I turn to look at Stephen's drawing and see that the spire cannot be included on the A4 paper. 'Bit difficult,' says Stephen. He gives me the unfinished sketch and Stephen is invited by the Russian artist to look at his paintings, one of which, a traditional landscape painting with a Byzantine church surrounded by trees, he gives to Stephen as a present.

The truth is that Stephen was more interested in the odd conversation which he was unable to follow and he was not concentrating on the drawing. The ink drawing illustrated here is drawn on Stephen's return home, with the pencil sketch to remind him of the building placed beside him.

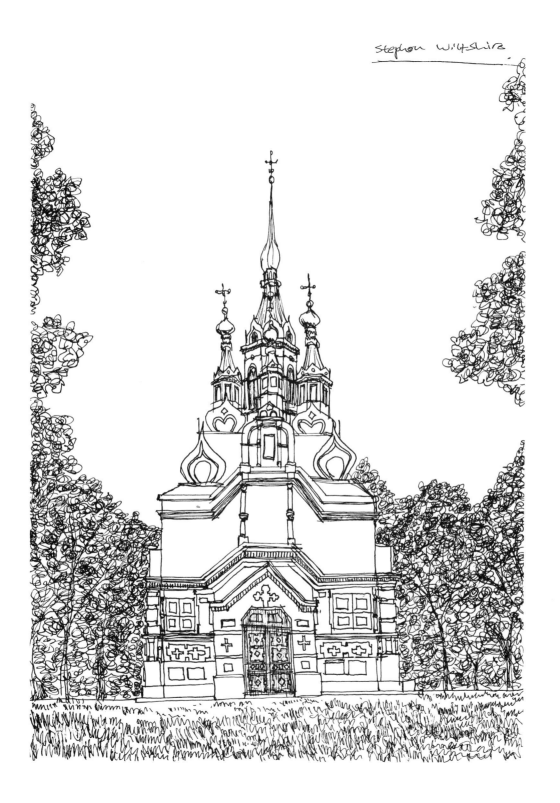

Stephen Wiltshire

GASTRONOME

The interior of this lavishly decorated grocer's shop in Gorky Street is chosen precisely because of its splendid decadence. We are surrounded by crowds of Russian shoppers and it is almost impossible to find an empty space to seat Stephen. I want Stephen to capture the entire space and ask him to draw the ceiling and not his eye-level view which would simply show the crowds. We seat him on his travelling stool and Jaqi and our Intourist interpreter are placed on either side of him to protect him from the surging swell of shoppers. It is extremely difficult to work in these surroundings but Stephen suggests that he will do a pencil sketch and complete the drawing later in pen.

The chandelier is drawn first, followed by the central show-case. The lines to denote the curve of the ceiling are sketched and a few pencilled grace notes suggest the ceiling decoration. There is not much in this pencil sketch to indicate the profusion of ornamentation. The fretwork decoration is omitted entirely and one of the cartouches behind the chandelier is left out. Stephen says, 'That's fine, I've got it', after twenty minutes.

The drawing is completed in pen in Leningrad three days later. Much of the detail that did not exist in the pencil sketch is now included. 'It's finished now,' says Stephen. I think it needs more detail, however, and a sharper contrast. I sit down beside him on a stool in the hotel bedroom and ask him to show me how the drawing could be improved.

'How will you make it sing? Can we have lighter and darker effects to suggest the density of the pillars and could the decoration be more defined?'

'Well . . .' replies Stephen.

He picks up the pen and the lattice-work trellis decoration is drawn. The pillars are darkened and the ceiling decoration is given far more detail. I am delighted and Stephen decides that now it is really finished. The only omission is the cartouche on the wall to the left of the chandelier. This is a curious omission because he invariably recognises symmetry. I decide not to mention it.

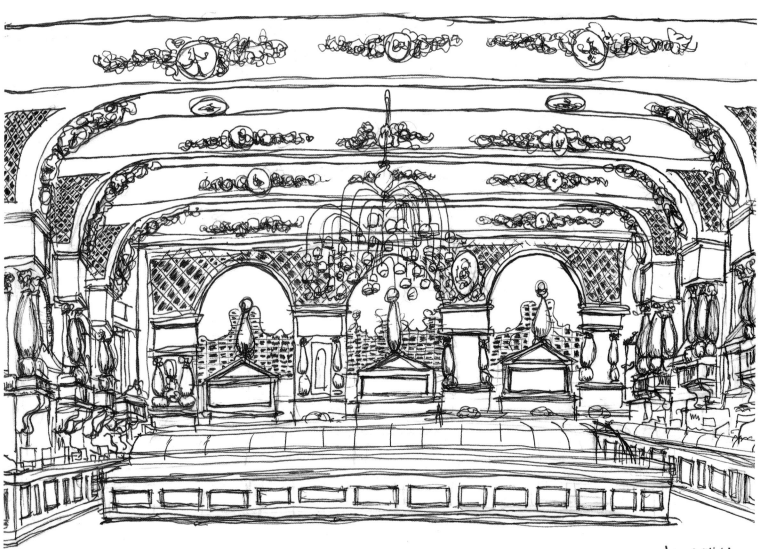

Stephen Wiltshire.

THE MINISTRY OF FOREIGN AFFAIRS

While waiting for our film crew, I take Stephen to the sixth floor of the Intourist Hotel where we are staying and ask him to draw this building which we can see in the distance. It is raining and the visibility is poor. Jaqi draws back the net curtains – and succeeds in pulling the entire curtain off its runners. We then clean the hotel window which is filthy, like all windows in this city. Clearly there is an abuse to visibility in Moscow. Oliver joins us and Stephen announces that 'This is a great building. Like New York, like sky scrapers.'

It takes Stephen twenty minutes to pen this Stalinesque 1940's edifice and the drawing is rendered all the more dramatic by his exclusion of the surrounding buildings.

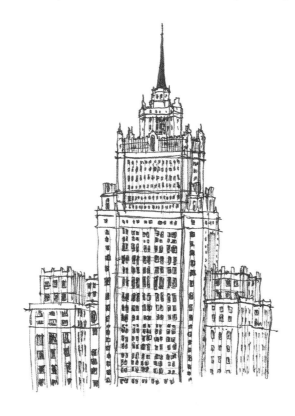

OUR LAST EVENING

Oliver, Jaqi, Tony Edwards and I take Stephen to the Baku Azerbaijan restaurant in Moscow where Belshazzar's Feast awaits us on the table. Oliver recounts a dinner he attended for two hundred Tourette Syndrome* sufferers in America and displays increasingly Tourettish mannerisms himself. Stephen is seated beside Oliver reciting one of his favourite dialogues from *Rain Man*, 'I'm an excellent driver . . .' and laughing to himself. A large party of Russians at another table are listening to a Soviet-style dissertation delivered by a middle-aged automaton but the guests become increasingly interested in Oliver's wild gestures and Stephen's diminutive frame beside him, now singing snatches of a Mel Smith song, 'Fa la la la Oh come on, shut up'.

Stephen suddenly stands up to announce in Russian the two words which are to become his constant refrain in Leningrad, '*Yá géni*' – 'I am a genius'. Oliver, who is totally unaware amidst the hubbub that all eyes are focussed on our table, gives Stephen his fan and asks to be fanned because it is extremely hot and Oliver's body temperature has a life of its own. Oliver carries the fan with him everywhere, except when he has mislaid it which is a frequent occurrence because, unwittingly, Oliver has elevated absent-mindedness to an art form.

This wonderful moment of role reversal is pure pleasure for Stephen. As the cartoon reveals, Oliver's large frame is reduced to cowering, diminutive proportions and Stephen's presence has assumed titanesque dimensions and his expression is quite demonic. Stephen *loved* it.

* 'Tourette's Syndrome is characterised by an excess of nervous energy and a great production and extravagence of strange motions and notions: tics, jerks, mannerisms, grimaces, noises, curses, involuntary imitations and compulsions of all sorts with an odd elfin humour and a tendency to antic and outlandish kinds of play' – *The Man Who Mistook His Wife For A Hat*, Duckworth & Co Ltd, 1985.

LENINGRAD

STEPHEN: *'Yá géni!'*

ST ISAAC'S CATHEDRAL

This imperious façade is Stephen's first drawing in Leningrad. It is chosen not for its aesthetic merits but to illustrate that, contrary to popular opinion, it is quite erroneous to think of Leningrad as an eighteenth-century neo-classical city. It has been in a continuous state of evolution since its founder, Peter the Great, died in 1725.

The cathedral was built by a French architect in the first half of the nineteenth century and stands beside the Astoria Hotel. The great cathedral dome can be seen in Stephen's panorama on page 139.

Stephen sits in the garden in front of the church, sketching the building in pencil. Neither of us feels any enthusiasm for the edifice and we are relieved when, after twenty minutes, we can abandon the drawing because it begins to rain. The drawing is completed later in the hotel, from memory.

What is more fascinating and intriguing about Stephen's drawings, and this one in particular, is his ability to communicate the graceless forms of specific buildings. There are few felicities contained within this structure and he captures the prosaic, uninspired language extremely well.

Stephen Wiltshire.

PALACE SQUARE

The two horses which frame this drawing form part of the Arch of Triumph. Stephen's pencil shading suggests the smooth texture of the horses; he intuitively recognises the aesthetic demands of his subject.

The drawing is taken from a photograph, and could not, for obvious reasons, have been rendered in any other manner. The Alexander Column, which celebrates the Russian defeat of Napoleon, and the baroque, festive yet solemn Winter Palace with its abundance of stucco moulding are suggested rather than meticulously defined. Note especially the detail in the far left-hand corner of this drawing as the buildings recede into the distance.

This is the main square of the city and its imposing architectural layout reflects its political importance. It has an authoritative heroic grandeur and is still the focal point of military parades today.

SMOLNY CONVENT

It is raining so Stephen draws this spectacular building from the bus. The driver wipes the window for Stephen and then returns to reading Pushkin. The central section is first drawn in pencil and the right wing is then sketched. He points to the wing on the left side and says, 'It's the same. I'll do it later.' He is seated first by the open door of the large bus with his pad placed on the front ledge beside the driver but then he moves to seat himself further back in the bus and grips his pad with his left hand to draw with the right.

This convent was built for Elizabeth, daughter of Peter the Great, by Bartolomeo Rastrelli. It is blue and white with golden domes. All baroque buildings are blue because Elizabeth had dazzlingly blue eyes. (The colour coding in Leningrad is as follows: blue – baroque, yellow – neo-classical, red – eclectic.) Officially, Elizabeth never married. Unofficially, she married a choir boy. Much loved by her people for her gaiety and enjoyment of life, she was hardly suited to convent life and indeed demanded of the architect that ballrooms should be included in the nunnery as she was passionately fond of dancing. According to our Russian guide, Elizabeth was a 'part-time' nun. She died before the building was completed and was never able to fulfil her part-time nun's fantasies. Oliver Sacks announces that this is a very common fantasy and confesses to part-time monk fantasies himself.

Stephen completes this drawing from memory, in pen, two days later.

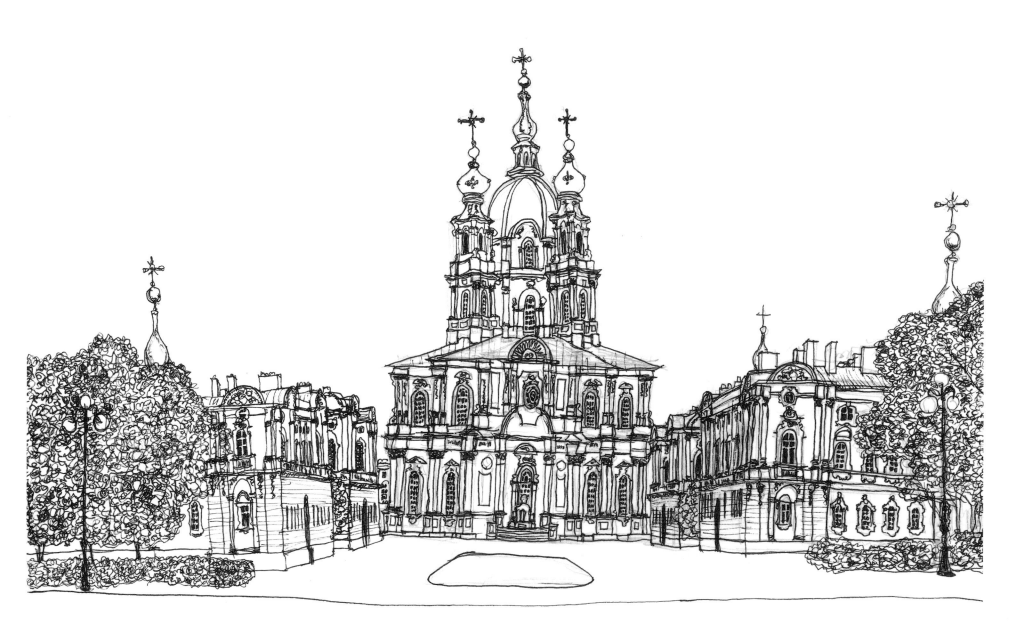

KIROV KOMBINAT

It is now raining hard as we leave Smolny Convent and drive to this factory which is the largest sewing thread factory in the USSR. The Kirov Kombinat is the new name for what used to be the Nevsky Cotton Spinning Mill and the Nevsky Thread Mill. The latter was built by the Scottish firm J. & P. Coats in 1889. The two companies amalgamated in 1897. The management of both companies at the time of their construction was British and this mill closely resembles J. & P. Coats mill, No 1 Spinning at Ferguslie, Paisley in Scotland.

The textile industry in Leningrad flourished during the latter half of the nineteenth century and this building is a fascinating example of industrial architecture.

Stephen sketches the building in pencil from the interior of the bus because the rain is now a downpour. Our bus is parked on the main road opposite the factory and Stephen seats himself at the back of the bus from where he can obtain the best available view. A ten-minute pencil sketch is completed. 'I'll pen it later,' says Stephen. The pencil sketch contains the broad outline of the building with a few windows drawn, four zigzag lines to denote the external staircases, no trees, no water and two rectangles at either side of the main structure. His memory provides the detail when this drawing is completed the following evening in our hotel bedroom.

Tourist Bus in Leningrad.

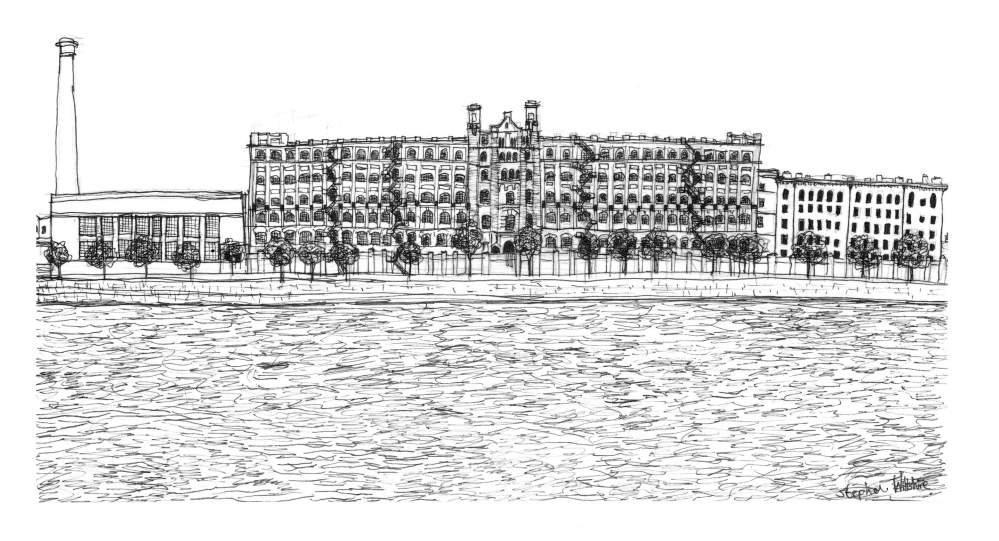

BRIDGE OVER THE RIVER NEVA

To those familiar with Stephen's work, the detailed architectural precision of this astonishing drawing will not surprise. The juxtaposition of the ancient Peter and Paul Fortress with the modern engineering feat of the bridge provides an opportunity to present Stephen with a dramatic visual contrast.

This illustration is done from a photograph because it could not have been drawn while we were in Leningrad. The bascule bridge never opened during our three-day stay in Leningrad but, had it done so, the detail of the bridge itself could never have been captured even by Stephen's x-ray eyes.

The Peter and Paul Fortress was built by Peter the Great to protect Leningrad from a Swedish attack. The Fortress appears on many postcards of Leningrad, illuminated at night. When I show Stephen a coloured poster of the Fortress across the Neva (illustrated without the bridge), he immediately says, 'It's just like Venice,' and indeed he is absolutely right.

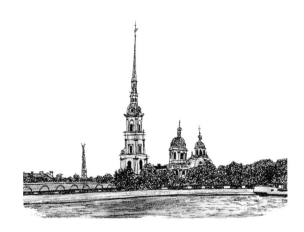

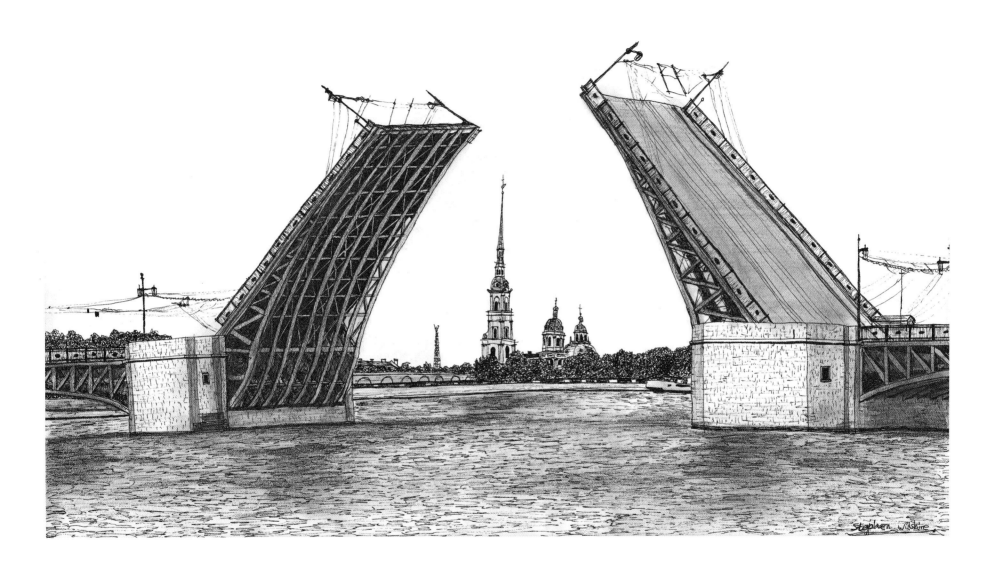

KATALNAYA GORKA

This palace is drawn from a colour photograph. The tiered wedding-cake structure has an infinite lightness. The double staircase and interestingly spaced columns which support the first-floor balcony allow Stephen the opportunity to demonstrate his technical mastery.

The palace was built as a pleasure pavilion for a day's amusement. Stephen and I are unable to visit the baroque palaces which form such a notable feature of Leningrad and its environments because we have only three days here, but this colour drawing gives an indication of their splendour.

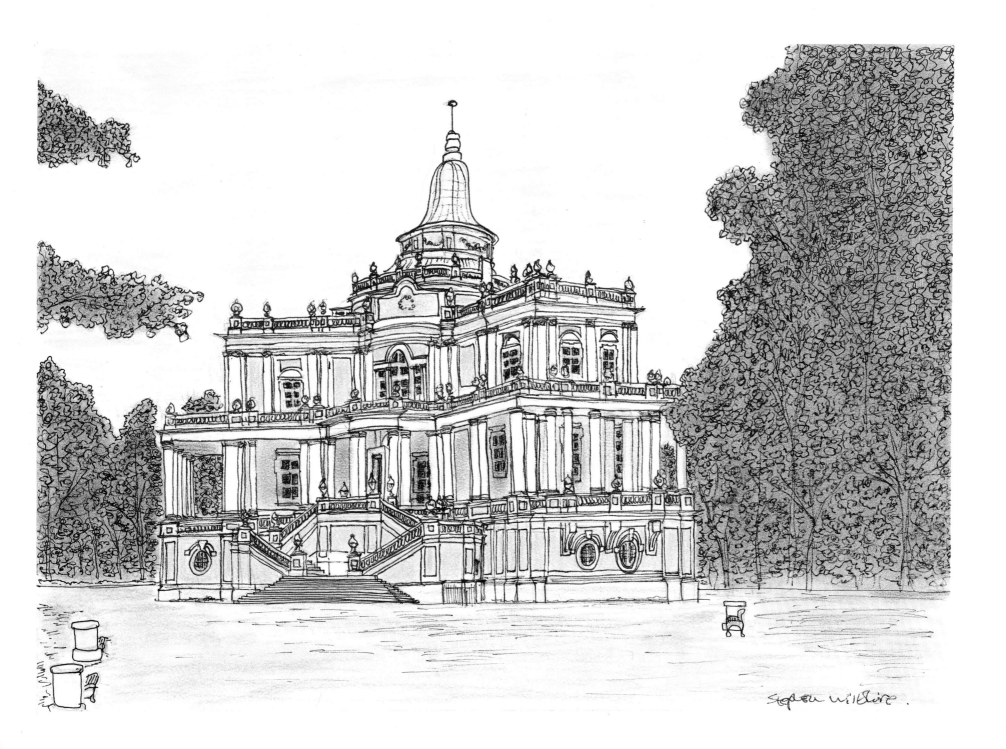

Stephen Wiltshire.

THE BELOSEL'SKY-BELOZERSKY PALACE

Stephen and I are standing on the bridge which crosses the Fontanka Canal. To our left is this large red nineteenth-century palace, a neo-baroque edifice similar to Rastrelli's Stroganov Palace (page 136). Leningrad contains much nineteenth-century architecture which echoes that of an earlier period. Stephen draws directly in pen and this canal view should be contrasted with the Amsterdam canal views to illustrate how different architectural styles determine the character of a city.

It is very cold and Stephen holds his pen in his gloved hands. Russian passers-by watch with delight and smile at Stephen. We spend thirty minutes on the bridge and Stephen finishes the drawing before we leave.

On the way home, Stephen quickly sketches the belfry of St Nicholas's Cathedral from a bridge over the Kurkov Canal. He completes the drawing in twenty minutes in pen when we get home.

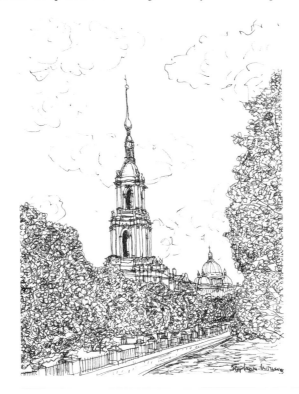

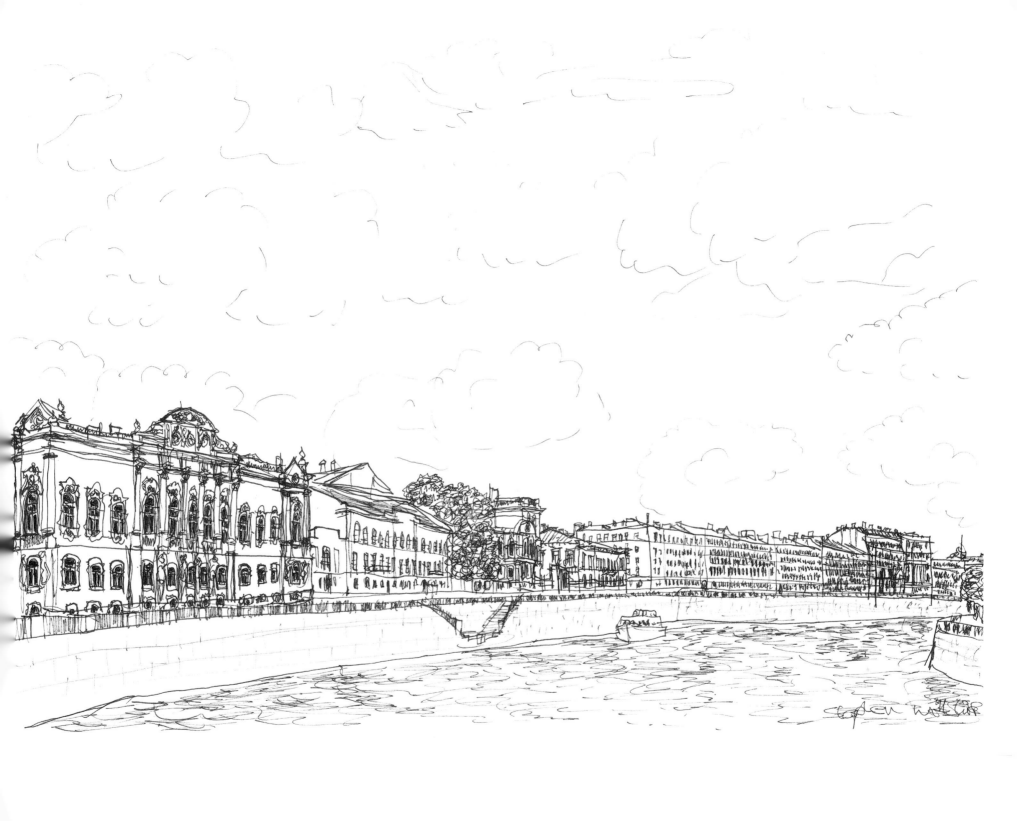

CHESMA CHURCH

This church is selected for its unusual pseudo-Gothic structure. Stephen draws it from a photograph and picks out the narrow, white vertical mouldings in pen and lovingly details the small pointed arches which terminate each white moulded stripe. The fanciful, bizarre nature of this Russian 'Gothick', with its toothed parapet, grooved walls and sharp pointed arches is exactly what Stephen achieves and is a perfect illustration of his ability to capture the 'character' of a building.

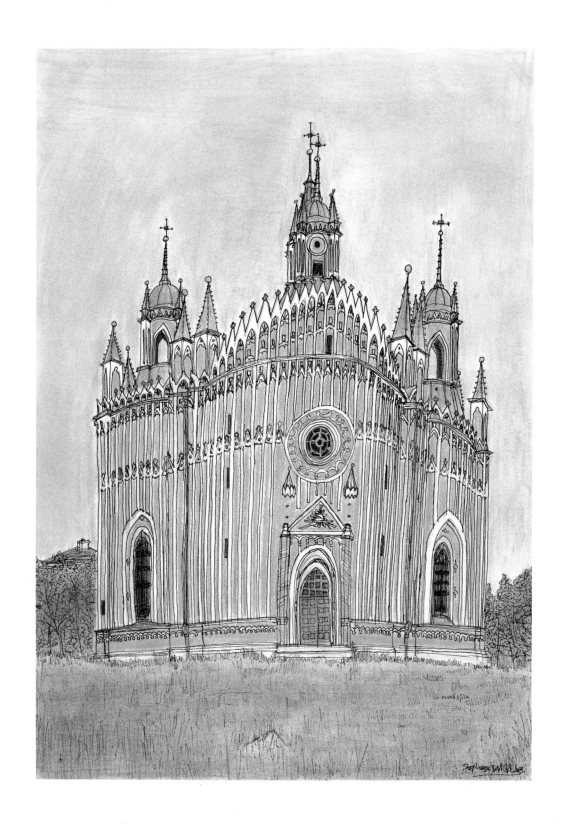

STROGANOV PALACE

The façade of the Stroganov Palace on the Moyka river serves to introduce Stephen to baroque architecture. This drawing is executed from a photograph prior to departure. It is a perfect example of Rastrelli's work – elegant and not overwhelmingly ornate. The decoration of the window surrounds is particularly appealing. The building is dark green and white and must represent one of the finest palaces in Leningrad. The Stroganovs were an eminent Russian family who commissioned the architect son of Carlo Rastrelli, the sculptor, to design this palace for them.

Much of Stephen's knowledge is acquired from photographs and their importance in his educational development can never be over-estimated.

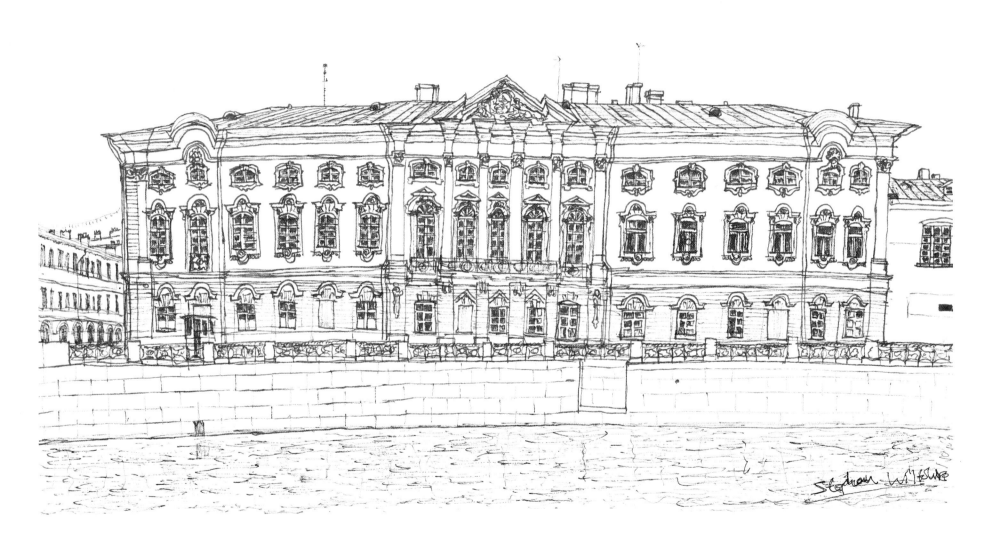

THE PANORAMA OF LENINGRAD

We are staying in the Leningrad Hotel and this is the view from Stephen's bedroom on the sixth floor. It is drawn directly in pen and illustrates the extraordinary skyline of this city: nine-tenths sky and one-tenth building. Catherine the Great decreed that all buildings in Leningrad were to be six feet lower than the Winter Palace.

The cruiser *Aurora*, renowned for having fired the first blank round which heralded the storming of the Winter Palace in 1917, lies to the right of the drawing with the Naval Officers' Academy behind. Across the River Neva, the dome of St Isaac's on the far right dominates the skyline and, to the left, the Church of the Resurrection, built on the site of Alexander II's assassination, can be seen covered in scaffolding. In front of this church, the trees form part of the thirty-acre Summer Gardens, the oldest gardens in Leningrad. The Kirov bridge can be seen in the distance. No detail escapes Stephen's omniscient eye and the smoke from the factory chimneys is also included.

Stephen starts this drawing early one morning before breakfast. After one interesting false start – because the cruiser is not in proportion to the buildings on the other side of the Neva: 'I'll just start again. It's no good. It won't work' – he tears off the first sheet of cartridge paper and begins again. The boat is penned first, then the buildings on the far left-hand corner with the shore line are outlined. He returns to the Naval Academy and the lime trees are crocheted. The drawing is abandoned after half an hour, to be completed later that evening when the bridge is drawn and the buildings from the Summer Gardens to the far right of the drawing are penned.

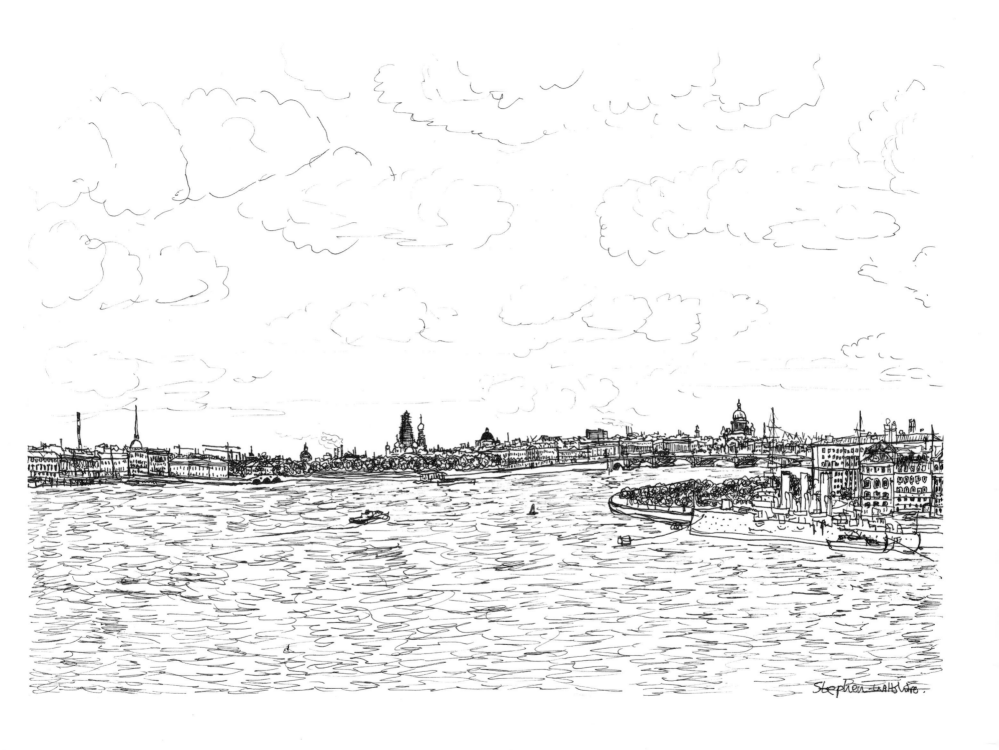

Stephen Wiltshire.

THE CHURCH OF THE RESURRECTION

When I first showed Stephen a photograph of this view prior to our Russian trip, he immediately said, 'It's St Basil's.' The numerous domes grouped around a tall tent roof is indeed a design which resembles that of St Basil's. In fact, this is the Church of the Resurrection of Christ, loosely based on the design of St Basil's. It is a nineteenth-century pastiche of the Russian style and was completed in 1907. The canal offers a dual vision – the buildings together with their reflection in the waters of the Griboyedov Canal. The trembling, shimmering nature of the reflected buildings and the liquid movement illustrate Stephen's refinement and subtlety of perception.

Russians call this the Church of the Saviour 'On the Spilled Blood' – a reference to the assassination of Alexander II who was killed by a terrorist bomb in 1881 as he was returning to the Winter Palace. The church is being restored at present and its garish presence and the crudity of its colours give it a decidedly odd appearance in the centre of Leningrad. It was exactly this style of Moscow architecture that Peter the Great rejected when he invited Italian architects to build Leningrad from a swamp. How ironic that it should be so celebrated by the people of Leningrad today.

I take Stephen to see the church while we are in Leningrad and am delighted when he says, 'I prefer St Basil's.'

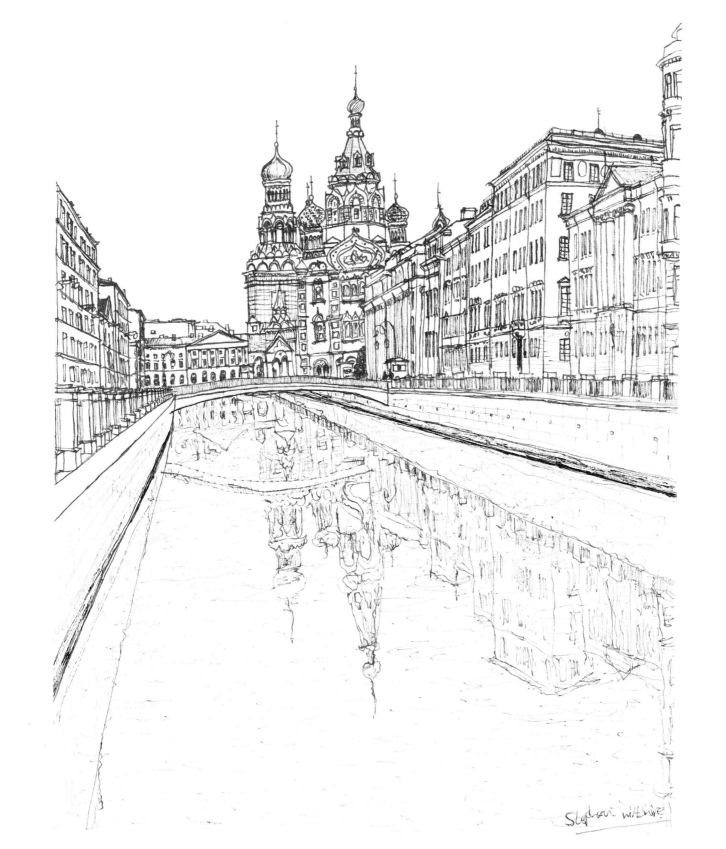

Stephen Wiltshire

THE ALEXANDER NEVSKY MONASTERY

Stephen, Oliver, Jaqi and I visit this monastery, founded by Peter the Great, the day before this drawing is executed. I want Stephen to draw aspects of this fabulous baroque ensemble but as we are walking around the buildings and enter the Cathedral of the Trinity, an eighteenth-century classical building unlike the rest of the monastery, we find ourselves in the midst of a Russian Orthodox wedding. I abandon all thoughts of drawing because the music and singing is emotionally powerful and the spectacle splendidly theatrical. There are probably no more than thirty wedding guests, the bride and groom look innocent, very young and vulnerable, and old Russian women with their pails of water and scrubbing brushes continue to clean the church floor despite the ceremony. A choir of five men and women, curiously dishevelled in appearance, is conducted by a blind woman with blank blue eyes and a wonderful smile. The bass voice could be Chaliapin who appears to have stepped out of the Gulag. We are hypnotised by the authority, splendour and majesty of their voices. It is electrifying and certainly explains the attraction of the Russian Orthodox Church. Stephen, however, does not appear to respond in any way to this experience and remains totally unaffected.

We all return the following day, together with Tony Edwards. Stephen and I stand on the bridge over the little Chornaya river which flows past the monastery. He is going to draw the buildings which form a rough rectangle surrounding the large wooded courtyard. Again, this is a pen drawing with no prior pencil sketch. He and I watch the mallard on the river as he draws. There is one duck, a day-old duckling and twelve drakes: most appropriate to the monastic setting.

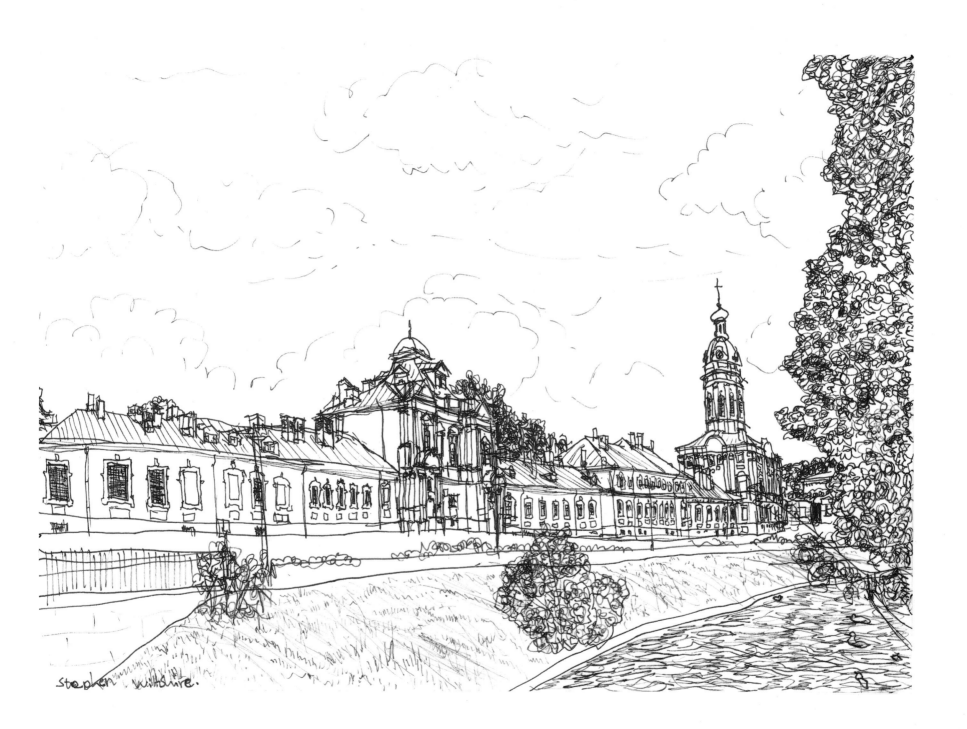

Stephen Wiltshire.

THE ALEXANDER NEVSKY MONASTERY:
The Tikhvin Cemetery

This cemetery, situated on the right of the entrance path to the monastery, was founded in the nineteenth century and is the burial ground for many eminent Russians, including Dostoyevsky and Tchaikovsky. Stephen pens the headstone of Dostoyevsky as we walk. The writer appears to have turned into Rasputin under the guidance of Stephen's pen.

The rain begins to fall as Stephen stands in front of Tchaikovsky's monument. We take it in turns to hold an umbrella over him as he pens the bizarre angel reading a Tchaikovsky score, perhaps. The angel with albatross wings in the background is penned. Stephen is smiling, maybe not quite sure why I have asked him to draw these headstones. The foliage is completed later, as is the attempt to reproduce the Russian script from memory.

Both drawings vividly suggest the spirit of religious sculpture monuments of the late nineteenth century, reminiscent of Père Lachaise cemetery in Paris. The clouds have been added by Stephen as an imaginative gesture.

THE MATISSE DANCERS

It is our last day in Leningrad and I want to take Stephen to the Hermitage to see the Shchukin and Morozov collection of French late-nineteenth- and early-twentieth-century paintings. I have ruled out a 'grand tour' of the museum and simply chosen what I think Stephen will enjoy. Our guide is informed that we want to go directly to this section of the Hermitage and we walk straight in through a side entrance.

My idea is to show Stephen Picasso's *Femme Nue* of 1912 and the Matisse *Dancers*. The Picasso is out on loan but, as Stephen's incredible colour drawing illustrates, the Matisse is exhibited. He stands in front of the painting for twenty minutes in silence as if hypnotised. He then studies an early Picasso cubist painting of *The Violin* for a further fifteen minutes before we walk around the rest of the collection.

On Stephen's return to London, he produces this colour drawing two days later. He has a postcard of the painting from which to copy but it is his memory of the original painting which actually inspires him. The result is truly celebratory.

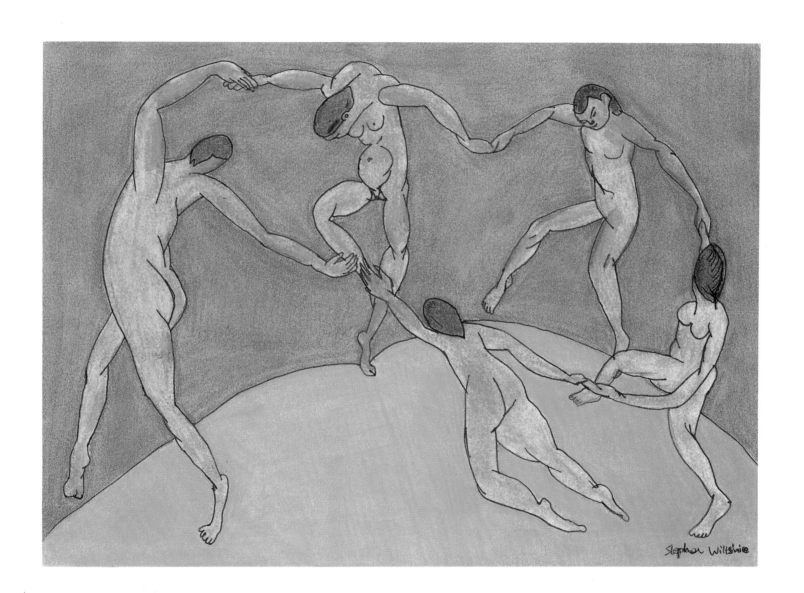